POSTCARD HISTORY SERIES

Old Salem and Salem College

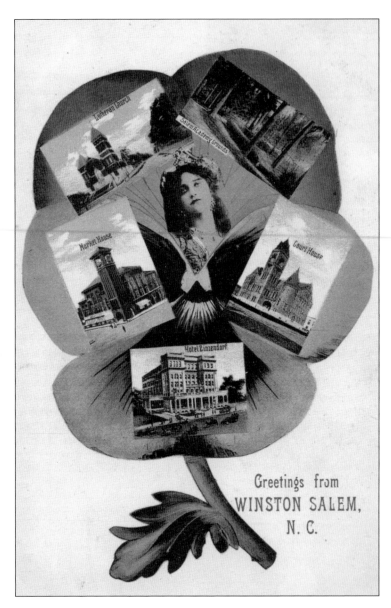

Greetings from
WINSTON SALEM,
N. C.

FIVE-VIEW PANSY FLOWER, 1910. The lady is surrounded on this novelty postcard by five well-known sites in Winston-Salem. The writer of this 1910-postmarked card reports that he has moved to the Zinzendorf Hotel, which is shown near the flower's stem. The other images are the Market House (town hall), Augsberg Lutheran Church, Salem Academy Pleasure Grounds, and the Forsyth County Courthouse. This is one of two known pansy postcards for the city. (Wayne and Louise Biby.)

ON THE FRONT COVER: Many of the buildings in Salem were arranged around the square, which in this postcard dated 1911 had a fence and a fountain in the center. Frederic William Marshall drew the plans for Salem, which consisted of a town square in the center, streets laid out in a grid, and a main street running the length of the ridge. Marshall also designed Home Moravian Church (center), which was built in 1800. (Author's collection.)

ON THE BACK COVER: Moravian women did not wear uniforms, but they did dress in similar fashion, such as this woman who is wearing the *haube*, a tight-fitting linen cap tied beneath the chin. She is wearing a pink ribbon on her cap, which indicates that she is a Single Sister. Cherry red was worn by the little girls, blue indicated that she was a Married Sister, and a white ribbon was for a widow. The Miksch House (right) and tobacco manufactory (left) are shown in the background. (Author's collection.)

POSTCARD HISTORY SERIES

Old Salem and Salem College

Molly Grogan Rawls

ARCADIA
PUBLISHING

Published by Arcadia Publishing
Charleston, South Carolina

Printed in the United States of America

Library of Congress Control Number: 2010926623

For all general information, please contact Arcadia Publishing:
Telephone 843-853-2070
Fax 843-853-0044
E-mail sales@arcadiapublishing.com
For customer service and orders:
Toll-Free 1-888-313-2665

Visit us on the Internet at www.arcadiapublishing.com

This book is dedicated to the Moravian men, women, and children who traveled to Piedmont North Carolina and established a town called Salem, with a church and schools for girls and boys, in appreciation for their steadfastness of character and for faithfully recording their lives so that we might know them and how they lived.

CONTENTS

ACKNOWLEDGMENTS

Many people contributed generously to the content of this book by granting access to their personal or their organizations' postcard collections. The book would not have as complete a coverage of the subjects without these contributions. The author appreciates the willingness of the contributors, and their names are indicated below, with the abbreviations that appear at the end of the captions.

Those who contributed postcards are Wayne and Louise Biby (WLB); Old Salem Museums and Gardens (OSMG); Moravian Archives, Winston-Salem (MA); Salem Academy and College Archives (SACA); Scott Venable (SV); Sarah Murphy McFarland (SMM); Janis Ware Cook (JWC); Mrs. Hanes' Moravian Cookies (MHMC); C. Harrison Conroy Company (CHC), Wachovia Historical Society (WHS); Clarke and Della Stephens (CDS); John Bullington (JB); Dr. Rose Simon (RS); Mary, Barry, and Rich Boneno (MBRB); and Werner Willis (WW). Postcards that are not attributed to the contributors listed above are from the author's personal collection.

The author also expresses appreciation to the individuals who granted access to personal and organizational collections and helped in the retrieval of these postcards. Special thanks go to Gary Albert, Abigail Linville, and Michele Doyle of Old Salem Museums and Gardens; Richard Starbuck and Bill Van Hoven of the Moravian Archives, Winston-Salem; Dr. Rose Simon of Salem Academy and College Archives; and Ramona Hanes Templin of Mrs. Hanes' Moravian Cookies. Also, thanks to Old Salem Museums and Gardens, C. Harrison Conroy Company, Werner Willis, Charlie Buchanan, and E. Alan McGee, who granted permission to the author to reproduce their postcards.

Special thanks are expressed to Dr. Rose Simon of Salem Academy and College Archives for her able assistance with historical information and to Dr. Michael O. Hartley and John Larson of Old Salem Museums and Gardens for their help in researching the postcard titled "Crist Bottom."

Jeffrey D. Rawls provided much appreciated help with all phases of the book, including scanning and preparing the postcards for publication and proofreading the manuscript. The author thanks Kevin M. Rawls for designing and maintaining her website, www.mollygroganrawls.com. And the author thanks her parents, Joseph C. and Angelia Grogan, for reading the manuscript and making helpful comments.

INTRODUCTION

It's hard to imagine a Winston without a Salem. And it's hard to imagine the time when the two towns were so separate, not only physically but in all other characteristics as well. Time has melted the borders and erased the outward appearances that marked the differences in customs and lifestyle. When we think about the beginnings of our city, we might wonder, "Just what was it like to live in Salem when it was a congregation town, and what was special about the Moravians, and what influence did they have on the city that is Winston-Salem?"

When I was a little girl, I sang one part of the "Morning Star" anthem during a church Christmas program. I often attended the annual Easter sunrise service in Old Salem and bought doughnuts at Krispy Kreme after the service. A Moravian star has hung in my parents' bay window at Christmas for as long as I can remember, and my mother made an advent wreath topped with a miniature Moravian star that she displays every Christmas. My family can hardly wait until my mother bakes her delicious Moravian cookies every December, because she shares them with all her children. Before we partake in a meal, we join hands and pray the Moravian blessing.

Every Christmas Eve, my immediate family attends a Moravian candlelight and lovefeast service, which reminds us of the reason that we celebrate Christmas. The decorated church sanctuary, the carols that the choir and band lead, the minister's Christmas message, the meal that is prayerfully shared, and the lighted and uplifted wrapped beeswax candles—all these elements combine to make a worshipful experience, and we leave the church with the words of the hymn in our hearts, "Hallelujah, God with Us."

Did I mention that I am and always have been a Baptist, and that I have yet to find a Moravian person in my family tree? I am sure that my experience is very similar to many others in Winston-Salem. I have grown up in a city where there are aspects of the Moravian life and culture all around, and I can't imagine it any other way.

When the historic town of Salem (from the Old Testament meaning "peace") was founded in 1766 by the Moravians, it was intended to be the commercial center for the Wachovia tract, which included much of Forsyth County. Salem grew and prospered in this role, and in 1913 Salem merged with its neighbor, Winston, to become the city of Winston-Salem. The homes and businesses in the historic town of Salem became modified and unrecognizable over the years, prompting a move in 1948 to create a historic district around Salem.

On March 30, 1950, Old Salem, Inc., was established as a nonprofit organization to acquire and preserve or restore "the historical monuments, buildings, sites, locations, areas, and/or objects" located in Forsyth County, North Carolina. Thus began the movement that has resulted in the restored Moravian town of Old Salem, a living museum of Moravian life in the 18th and 19th centuries.

The original historic district was expanded twice since its founding, and approximately 150 structures were removed that did not contribute to the historical landscape. Recently a new visitor center was built with a large auditorium that features a restored Tannenberg organ and

has facilities for individuals and groups to be introduced to the story of Old Salem. The visitor center is connected by a covered wooden bridge to the historic district, where buildings continue to be restored, such as the 1861 African American Moravian church called St. Phillips.

The education of the children was important enough to establish separate schools for the boys and girls in the very early days of Salem. In April 1772, Sister Oesterlein established a school for young girls in the Gemein Haus, where the Moravian Single Sisters first lived. Just a few girls attended in the beginning, but the school gradually added subjects to the curriculum, and more teachers joined the faculty to meet the demands as more girls came to the school. A girls' boarding school was begun in 1804, housed in the new South Hall that was built in 1805 for that purpose. The school for town girls, combined with the boarding school, became the foundation for Salem Academy and College.

The history of Salem Academy and College is a fascinating story on many levels, as it combines the local community's influence with the changing social times in which the school was a part. For example, during the Civil War, many families from all over the country sent their daughters to boarding school in Salem for their protection. Even when the country was ravaged with warring troops, the girls were fed, clothed, protected, and educated, as the school did not close even in those trying times.

It seems that every generation sees trying times, and the school has weathered the ups and downs of social and financial change. Salem has always been a girls' school, but men were admitted after World War II, as the educational institutions all around were filled with GIs who wanted to begin or continue their education. Salem Academy and College is devoted to providing a quality education to prepare women for today's challenges while surrounding the students with a sense of history. Winston-Salem has been the beneficiary of both attracting the women to the school and their education, as many Salem graduates have chosen to stay in Winston-Salem to live and work.

The postcards and their captions show and tell the story of Old Salem and Salem College in this pictorial history. The postcards in the book were chosen to present as thorough a view of the subject as possible, with the only limitation being the existence of a postcard on a particular subject.

Deltiologists, or postcard collectors, will recognize several types of postcards that are used in the book. The oldest postcard is the private mailing card (1898–1901), followed by authorized "postcards" with undivided backs (1902–1907). The divided-back era began in March 1907, with the golden age of postcards considered to be between 1907 and 1915. Other postcards in the book are from the white border era (1915–1930), linen era (1930–1950), and chrome era (1939–present).

Real-photo postcards are not attached to an era but consist of a photograph stamped or printed with the design elements required for mailing. Real-photo postcards, such as those on page 18, are prized for capturing local places and people. The challenging and heartbreaking part of these cards is that since they were not printed with identifying information, many are classed as miscellaneous in antique stores, and their stories are lost.

Just as every photograph has a story to tell, so does every postcard. While I have attempted to covey these stories through the captions, sometimes I have more to say than the counted words will allow. Interested readers are invited to visit my website, www.mollygroganrawls.com, to read more about the people and places that had a part in the history of Old Salem and Salem College.

One

A Town Called Salem

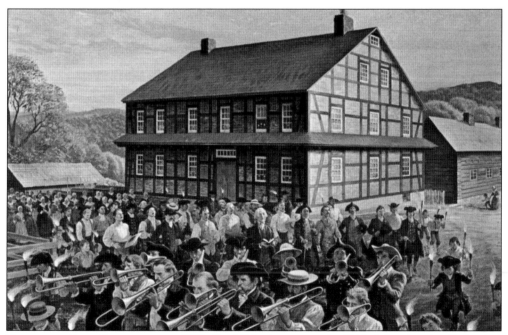

FOURTH OF JULY CELEBRATION, 1783. Established as a town in 1766, Salem has the distinction of forging many "firsts" during its early years. This painting commemorates Salem's 1783 Fourth of July celebration, which was held as a "Day of Solemn Thanksgiving to Almighty God" for the restoration of peace following the American Revolution. The Moravian Band is shown in the foreground, with the Single Brothers' House and workshop in the background.

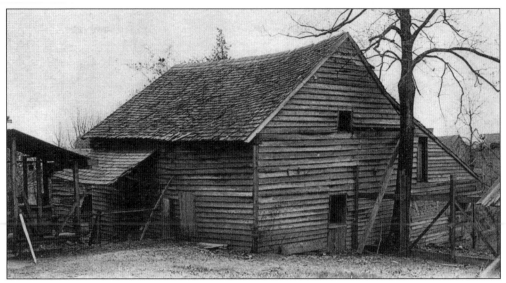

OLDEST HOUSE, 1906. One hundred forty years is a long time for a wooden house to stand. But the oldest house in Salem was still standing when this postcard was mailed in 1906. Trees were cut at this location by the Brethren in January 1766, and the foundation stone was laid in June. Gottfried Praezel moved in with his loom in October. The house stood at its Main Street location until 1907.

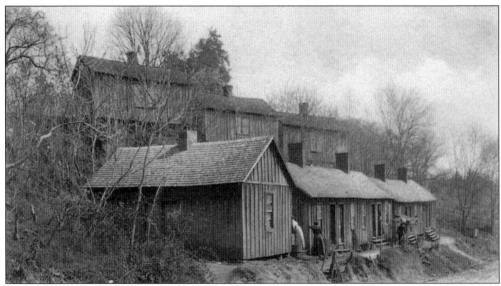

CRIST BOTTOM. Rudolph Christ (or Crist) walked from Bethlehem, Pennsylvania, to Bethabara in 1764 with the first group of 12 Older Boys. He came to learn a trade from the craftsmen in Wachovia, and the trade that he chose was making pottery. The Salem potters dug their clay in a bottomland area below the tenement houses shown in the postcard. The houses were located where the Bahnson Dormitory on the Salem College campus is today. (MA.)

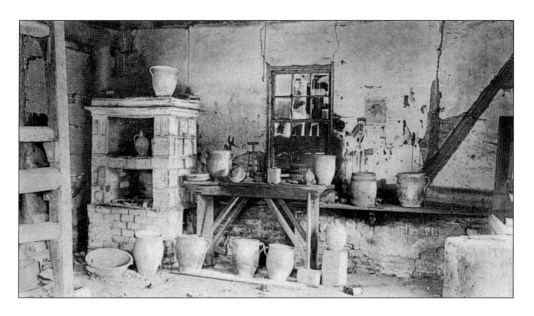

POTTER'S SHOP, 1905. One of the many Salem craftsmen was the potter. His work was in demand for the everyday plates, pans, and vessels used in a home as well as for the decorative accent pieces. Gottfried Aust was Wachovia's first potter, and he came to Salem in 1771 from Bethabara. The early pottery shop was located on the corner of Main Street and Fish Alley. Other potters who followed Aust were Schnepf, Christ, Holland, Schaffner, and Krause. Part of the pottery building was acquired for the Salem Concert Hall. The pottery room (above) was probably located in the Oldest (or Builder's) House, which was used as a pottery in the 19th century. The plate (below), an example of slip decoration by Friedrich Rothrock, is signed with the potter's initials. The plate is part of the Old Salem Collection.

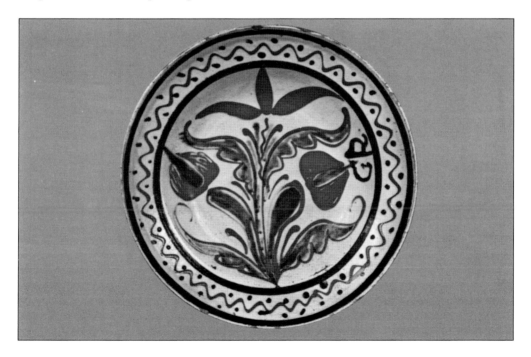

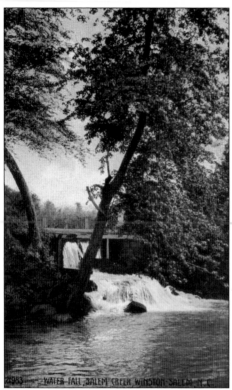

SALEM CREEK WATERFALL. One requirement in selecting a good location for a new settlement was a constant source of water. Bishop August Gottlieb Spangenberg led the expedition to select a site for building a settlement in North Carolina. The Wachovia tract was so named because the landscape reminded Bishop Spangenberg of an estate in Austria called Wachau, meaning "meadow along the Wach." The main stream in the Wachovia tract was also called the Wach, but the name was later changed to Salem Creek.

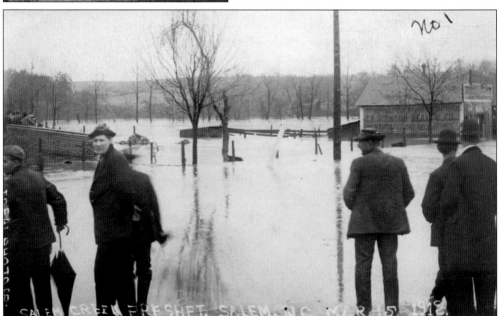

SALEM CREEK FLOOD, 1912—LEFT. Place this postcard next to the postcard on the opposite page and experience the Salem Creek flood to the fullest. The rains that fell during the day on March 15, 1912, caused a quarter of a million dollars' damage in Forsyth County. Thousands of spectators traveled by car and streetcar to view the flood. Southside residents were stranded in Winston, unable to cross the creek until late in the evening. (OSMG.)

SALEM CREEK FOOT BRIDGE. Floods proved to be hazardous for early bridges, such as the bridge built in 1771 over the creek in conjunction with Salem's first mill. With Salem Creek in such close proximity to the town of Salem, there were many bridges built to provide paths for pedestrian traffic, to accommodate tracks for the streetcar to follow, and later to carry the cars and trucks that crossed over Salem Creek.

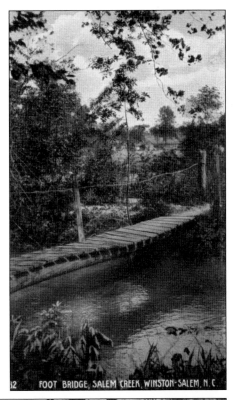

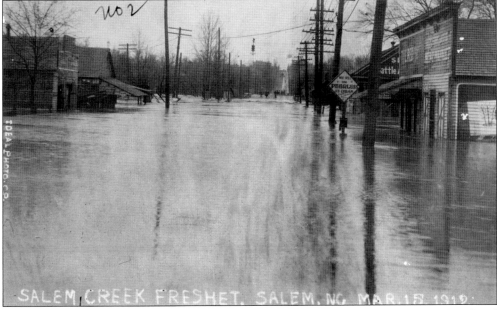

SALEM CREEK FLOOD, 1912–RIGHT. Bridges were washed away, roads were damaged, railroad traffic was halted, and some businesses were flooded. Of great concern was the Winston water supply, because the flood destroyed the embankment at the concrete dam. The Salem water plant was submerged, but there was no lasting damage. Forsyth County farmers received the greatest loss from the fields that were washed out and gullied. (OSMG.)

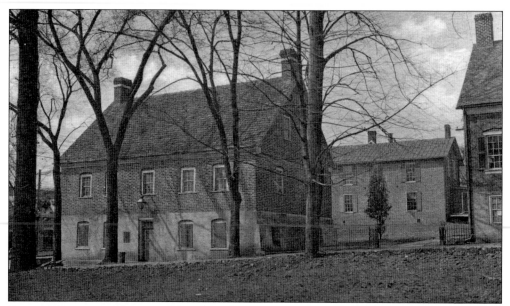

SALEM HISTORICAL MUSEUM. Salem boys from 6 to 14 years of age attended school in the 1794 building on the northeast corner of Main and Academy Streets. The Boys' School moved to a new location at Church and Bank Streets in 1896, leaving the two-story building vacant. The Wachovia Historical Society, formed in 1895, purchased the building to house its collection of historical artifacts. The society operated the Wachovia Museum until the early 1950s. (SV.)

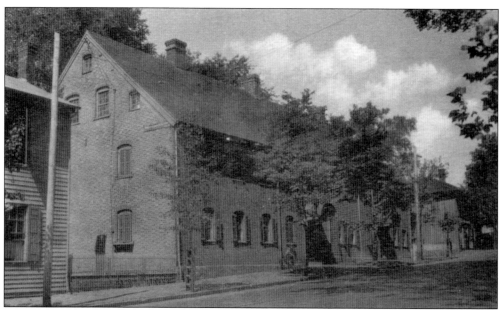

WIDOWS' HOUSE. The widows of the congregation lived in a house built in 1783. The decision was made in 1842 to move the widows from their dilapidated house to the former Single Brothers' House at Main and Academy Streets. The Single Brothers' House closed in 1823 and was then used for a variety of purposes, such as a boys' boarding school and as a practice location for the church musicians.

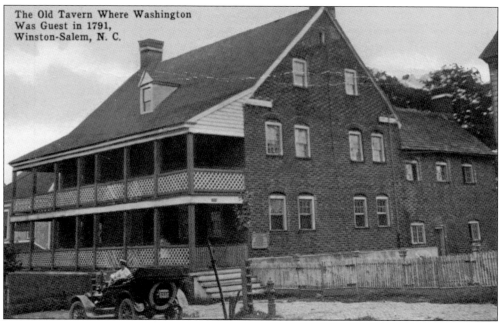

The Old Tavern Where Washington Was Guest in 1791, Winston-Salem, N. C.

SALEM TAVERN. Travelers often came to and through Salem, and the tavern (above) offered food, beverages, and lodging for hungry and weary guests. As the plaque (below) indicates, the tavern was one of the first public buildings constructed in Salem, being built in 1771 on Main Street. A fire in 1784 destroyed the building, and a new tavern was quickly built during the same year. While guests were welcome in town, particularly for business purposes, any "strangers" were watched cautiously to prevent inappropriate behavior. There were several tavern keepers over the years, but only one, Adam Butner, actually owned the tavern and the lot. Butner bought the tavern and lot in 1867 and operated it until his death in 1884. He and his wife had previously operated it from 1850 to 1858. Some postcards refer to the tavern as the Butner Hotel for this reason.

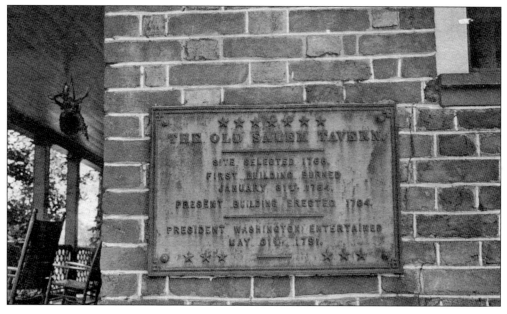

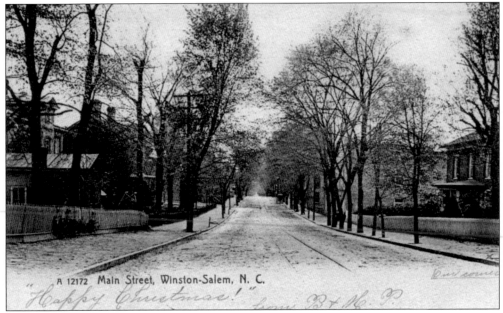

A 12172 Main Street, Winston-Salem, N. C.

"Happy Christmas!"

SOUTH MAIN STREET, C. 1908. Bessie and Maggie Pfohl sent the above postcard with "Happy Christmas!" inscribed on the front and added an asterisk in the lower right-hand corner with "our corner" written beside it. Over 100 years ago, this tree-lined street was the gateway to Salem. Homes and businesses were located side by side. Looking south from First Street, the Christian T. Pfohl house is out of sight to the right, but part of the Frank H. Vogler house can be seen behind the fence. Next door is the undertaking business of A. C. Vogler and Sons. Across the street to the left is Dr. J. C. Watkins's dentist office, next door to the home of Mrs. F. O. Watkins, with Dr. Copple's Sanitarium on the corner. The postcard below gives an opposite view, showing the streetcar moving south toward the Coffee Pot at Belews Street. (Above, MA; below, WLB.)

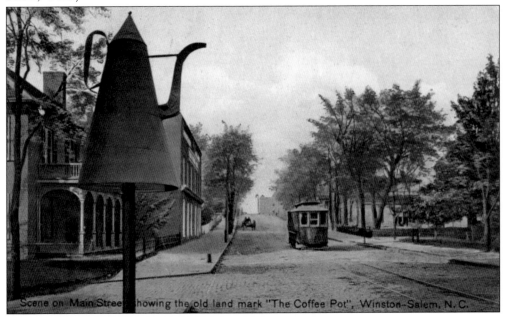

Scene on Main Street showing the old land mark "The Coffee Pot", Winston-Salem, N. C.

200 Block of South Church Street. Two gentlemen strike a leisurely pose beside the fence at the Edward W. Leinbach house at 235 South Church Street in the above postcard. The photographer stood on Cemetery Street with his back to the Salem graveyard. Next door, at 227 South Church Street, lived another Leinbach family consisting of brothers James and Julius and Julius's family. The 1858 house, with its gingerbread trim, can be seen in the postcard below. Julius Leinbach was known as the "star-maker," for he made the first multi-pointed Moravian star hung in Home Moravian Church. He also made many other stars by request over the years. Moravian stars are still popular adornments for homes and churches in Winston-Salem, and Julius would probably approve of today's easier-to-assemble models. (Above, WHS; below, OSMG.)

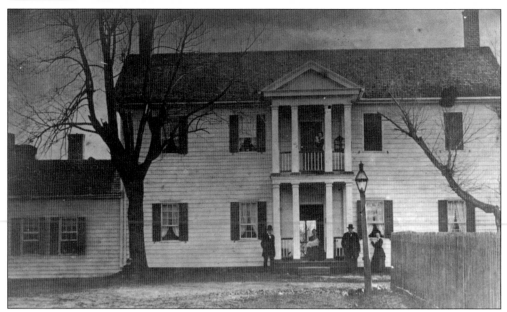

REICH-HEGE HOUSE, CHURCH AND RACE STREETS. Emanuel Reich, a shoemaker, built his house at the end of South Church Street in 1831. George Hege bought the house in 1851 and enlarged it to the two-story building shown above. George Hege owned Salem Mill, the first gristmill built in Salem. George and his wife, Polly, are shown at the center of this photograph. The house was later demolished, and Central Park School was built on this lot in 1924. (MA.)

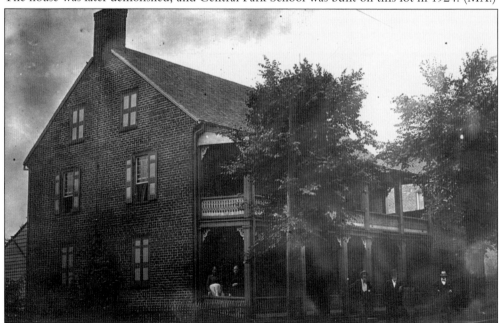

HENDRIX HOUSE, 234 SOUTH MAIN STREET. The two-story house with a double front porch belonged to Lee Hendrix (or Hendricks) and was located in the 200 block of South Main Street. Situated right on the street, as were most of the houses, the Hendrix residence also had a single-story extension to the north. Lee Hendrix (1834–1902) was married first to Martha Louisa Fisher (1838–1882) and second to Emma Lucinda Shore (1838–1912). (SACA.)

VANCE HOUSE, 316 EAST BELEWS CREEK STREET. Joseph A. and Annie Vance lived in this large, two-story house on the corner of East Belews Creek and Water Streets. Vance worked for Fogle Brothers Lumber Company, located across the street, before he organized the J. A. Vance Iron Works in 1884. Vance served as mayor of Salem for two terms, was chairman of the Forsyth County Commissioners, and was an alderman in Salem.

NADING HOUSE, 135 SOUTH CHERRY STREET. Henry A. Nading married Mary Louise Montgomery in 1913, and they moved into this house on Cherry Street. Their neighbors in the fashionable neighborhood were H. Montague and William F. Shaffner. The Nadings lived here until about 1922 and then moved to Summit Street. The car parked to the right is a Hupmobile Runabout, manufactured by the Hupp Motor Car Company. (SV.)

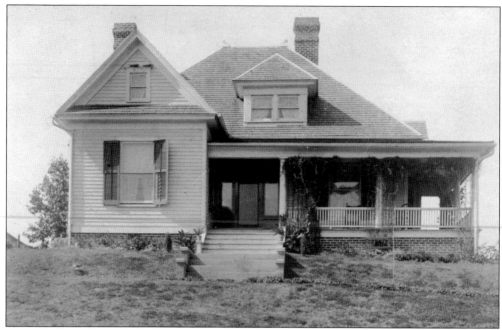

GEORGE A. BOOZER HOUSE, SOUTH MAIN STREET. In the early part of the 20th century, the Southside neighborhood was considered too far out of town to list the houses by street name in the city directories. George A. Boozer and wife, Alma Carmichael Boozer, lived at the 1400 block of South Main Street. The couple was married in 1890, and George Boozer worked as a bookkeeper for the Marler-Dalton-Gilmer Company. (OSMG.)

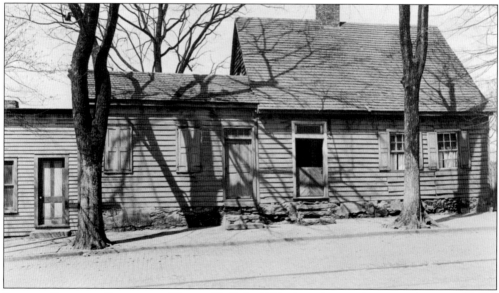

JOHANN GOTTLOB SCHROETER HOUSE. Built in 1805, the Schroeter house and tailor shop was located at 520 South Main Street. After Schroeter died, the house was purchased by Benjamin Warner, a tobacconist. His son Massah was born in this house and is best known as a famous piano teacher and the writer of the hymns "Softly the Night is Sleeping" and "The Lord's Prayer." The house was reconstructed to its 1832 appearance. (OSMG.)

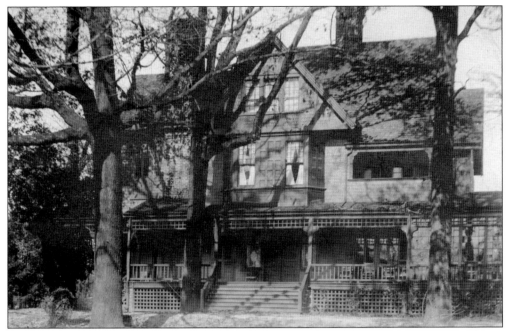

HYLEHURST, 224 SOUTH CHERRY STREET. Margaret Blair McCuiston, granddaughter of John Wesley Fries, was born at Hylehurst and lived most of her married life at this address. When she was a little girl, she lived next door with her parents, William and Mary Fries Blair, her sister Marian, and her brother John Fries Blair. Dr. Adelaide L. Fries, Moravian archivist and historian, also lived at Hylehurst. (SV.)

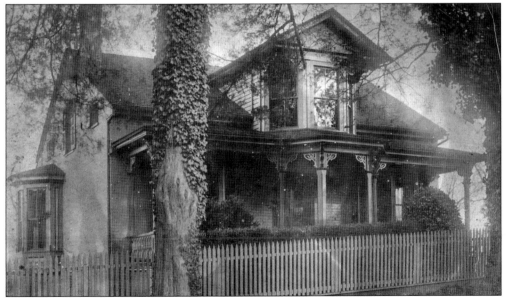

KREMER HOUSE, 455 SOUTH CHURCH STREET. Charles Kremer and his wife, Eliza Vierling Kremer, built their one-and-a-half-story brick house on Cedar Avenue in 1841. They were careful not to disturb the cedar trees that gave the avenue its name. Sisters Maria and Regina Vogler later lived in the house and willed it to the Moravian Church. Most recently, the Moravian Ministries Foundation in America uses the house for its headquarters. (OSMG.)

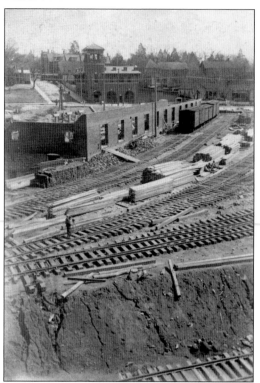

SOUTHBOUND RAILWAY FREIGHT STATION, 1913. The Winston-Salem Southbound Railway was established in 1910, and a new freight station (foreground) was under construction on South Liberty Street in 1913. Salem Town Hall (with the tower), built in 1909, can be seen on the opposite side of Liberty Street in the distance beside Cemetery Street. Salem's town business was conducted from the top floor, while Salem's fire department occupied the lower floor of the building. (OSMG.)

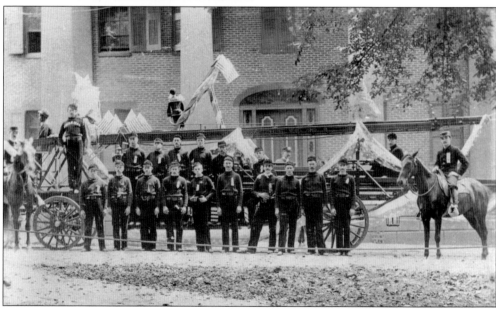

FIREMEN IN FRONT OF MAIN HALL. The firemen of Winston Fire Department Hook and Ladder Company No. 2 stand at attention in front of Salem College's Main Hall. The wagon is decorated with flags and bunting in honor of the Firemen's Association Tournament held in the city. The local firemen are wearing a ribbon to distinguish them from the visitors. The Salem Band played in the parade of decorated wagons of fire departments from all over North Carolina. (OSMG.)

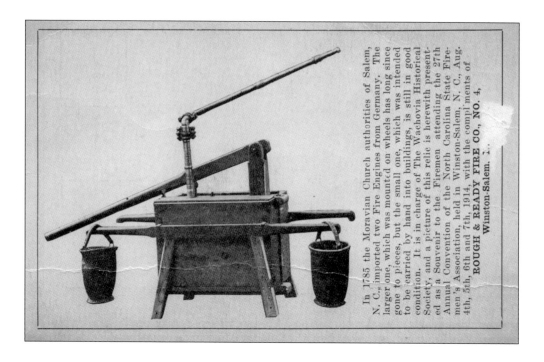

In 1785 the Moravian Church authorities of Salem, N. C., imported two Fire Engines from Germany. The larger one, which was mounted on wheels has long since gone to pieces, but the small one, which was intended to be carried by hand into buildings, is still in good condition. It is in charge of The Wachovia Historical Society, and a picture of this relic is herewith presented as a Souvenir to the Firemen attending the 27th Annual Convention of the North Carolina State Firemen's Association, held in Winston-Salem, N. C., Aug. 4th, 5th, 6th and 7th, 1914, with the compl'ments of ROUGH & READY FIRE CO., NO. 4, Winston-Salem. N. C.

NORTH CAROLINA STATE FIREMEN'S ASSOCIATION TOURNAMENT, 1914. Winston-Salem had previously hosted the state association meeting in 1894 and 1905, and the local firemen knew how to entertain their guests. In August 1914, the meetings took place on the first day, and the next three days were devoted to parades, contests, races, gun shoots, and baseball games. The parade was arranged to show the evolution of firefighting apparatus, and leading the parade was the first fire engine imported by Salem in 1785. A photograph of the engine was made into a souvenir postcard, seen above, for the visiting firemen. Many of the races involved horse-drawn hose wagons. The racetrack, on Cherry Street between Fourth and First Streets, is shown in the postcard below. Cherry Street was considered ideal because it was paved and had many shade trees. (Above, SV; below, OSMG.)

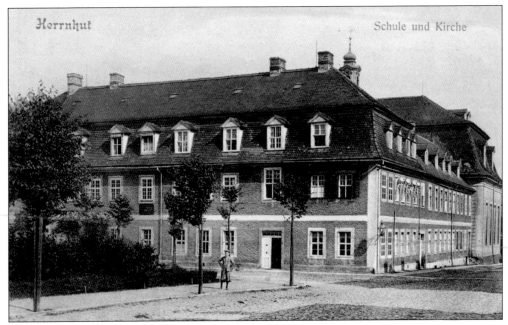

HERRNHUT SCHOOL AND CHURCH. Count Nicholas Ludwig von Zinzendorf permitted a small group of Moravians to settle on his vast estate in the German state of Saxony. The communal town formed by these settlers was named Herrnhut, meaning "under the Lord's watch" and "on watch for the Lord." It was at Herrnhut that the first Easter sunrise service was held in 1832, beginning a tradition for Moravians that continues to today.

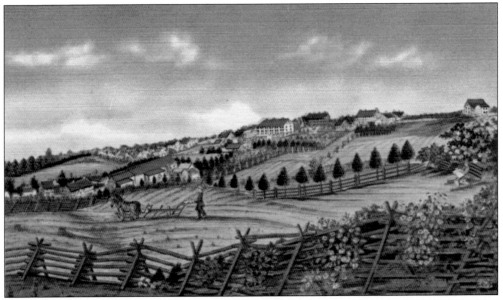

A VIEW OF SALEM IN N. CAROLINA–1787 BY VON REDEKEN. Artists such as Ludwig Gottfried von Redeken made valuable contributions to the historical record because of the landscape detail that they incorporated into their drawings. This view of Salem is more than just a pretty watercolor, for it documents the lay of the land as well as the placement of fences and some of the architecture and location of buildings.

24

VORSTEHER'S HOUSE. The house at 501 South Main Street was built in 1797 to serve as the home and office for the *vorsteher*, the business manager for the Salem congregation. The first occupants of the house were Brother and Sister Samuel Stotz. An unusual architectural feature of the house is the A-shaped hood over the front entrance. The last business manager was Samuel T. Pfohl, who retired in 1873, and the Salem congregation made the decision to incorporate in 1874. The Archives of the Southern Province were housed in the Bishop's House and moved from there to the Vorsteher's House in 1878. The archives had a few more moves until they returned to their previous home in 1942, which was by then a fire-resistant repository. The archives resided here until the Archie K. Davis Center was built in 2001. (Right, OSMG; below, MA.)

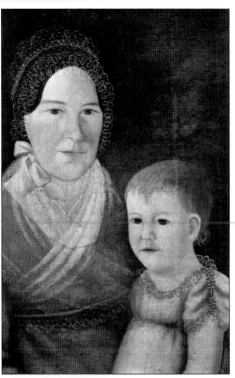

REUZ PORTRAIT BY DANIEL WELFARE.
Christian Daniel Welfare was the first
Salem-born portrait and landscape artist to
work in Salem. He held a variety of jobs
during his life, even serving as Salem's
tavern keeper for nearly two years. Welfare
studied painting in Philadelphia for 20
months and produced several portraits, such
as the one shown here of Elisabeth Reuz
and her son Samuel Zacharias Reuz.

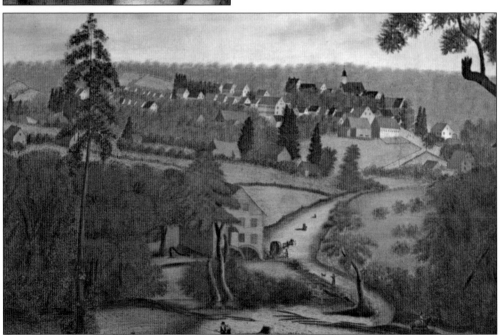

SALEM FROM THE SOUTHWEST **BY DANIEL WELFARE.** In addition to the portraits, Welfare also
painted landscapes, such as this view of Salem. At one time, Welfare operated a gallery for display
as well as a place for him to paint. Welfare established a lifelong friendship with artist Thomas
Sully while in Philadelphia. Welfare even named his son Thomas Sully Welfare after his friend
and mentor. (WLB.)

Two

HISTORIC OLD SALEM

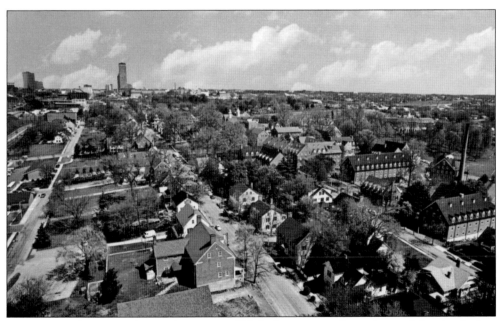

OLD SALEM AERIAL. The southern part of Main Street was a busy thoroughfare in the late 1940s. Salem's historic houses and businesses gradually began to blend into the 20th century until Salem's identity was lost. A group of concerned citizens sought and won designation for Salem as a historic district in 1948. Old Salem, Inc., was established in 1950 to restore Salem to the town that would make its Moravian forefathers proud.

SALEM SQUARE. Frederic William Marshall, Wachovia's first chief administrator, had a design in mind for the town of Salem. An important aspect of the design was the town square, because all the important buildings would be arranged around and the principle activities would take place on the square. He wanted the area to be as level as possible and to function as an open plaza. While the square has taken different looks over the years, it has always been at the center of Salem activities.

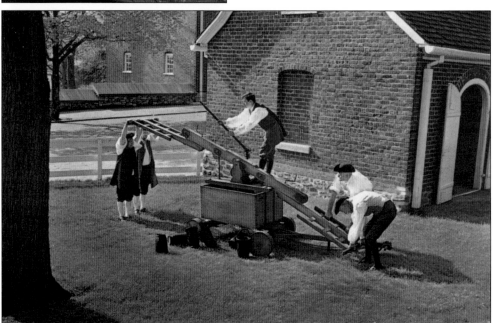

SALEM FIRE ENGINE. The threat of fire was always taken seriously in Salem, and precautions were taken to guard against starting fires in all buildings. After the tavern burned in 1784, even more attention was given to making sure that the fire engines were in working order. The smaller engine being demonstrated in this photograph was useful for small blazes and for fighting fires inside of buildings.

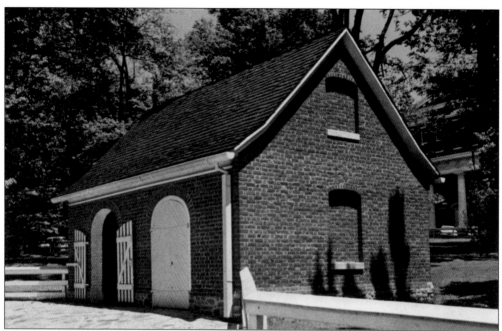

MARKET–FIRE HOUSE. The building located on the square was the Market–Fire House, a combination of a fresh meat market and a house for storing the fire engines and the buckets that held water for the bucket brigade. The market house was established when Dr. Samuel Benjamin Vierling encouraged Salem residents to eat more fresh, rather than salted, meats. Once a week, fresh meat was delivered to the market house, announced by the blowing of a conch-shell horn.

WATER SUPPLY CISTERN. Salem's waterworks system was designed in 1778 with five stations in town where water could be obtained. One of the five stations was at the southwest corner of the square, opposite the Community Store. The water system worked by gravity, flowing from a spring northwest of town through wooden pipes. A second waterworks system was installed in 1828, and a third in 1878. The public cistern and hand pump have been reconstructed.

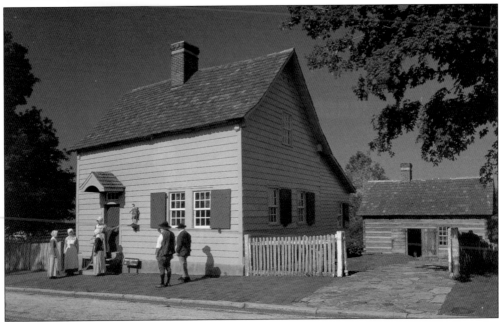

THE MIKSCH HOUSE. Matthew and Henrietta Miksch moved to Salem from Bethabara and built the yellow house on Main Street (above) in 1771. The original house, the first built in Salem for a single family, consisted of two rooms and a foyer until an addition enlarged the living and shop space. The Miksch family supported themselves through several business ventures over the years. They farmed land in the square for a while. They also made and sold candles, along with their homemade gingerbread and the bread made by the Single Brothers. Brother Miksch processed and sold tobacco. The tobacco business grew, and the tobacco manufactory (above, at right) was built in the back of the house. The stove (below), used for heating, was made of tiles glazed with a yellow slip over which are brown lines and green splotches.

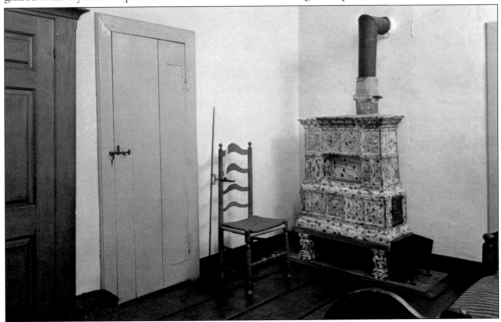

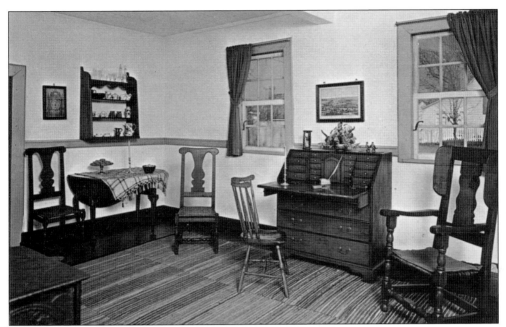

THE MIKSCH HOUSE INTERIOR. The "best room" of the Miksch house, seen above, served many purposes for the family. In addition to being a family room, it was an office and a store. The Miksch shop was sometimes referred to as an "odds and ends" shop because of the variety of products for sale. When Brother Miksch farmed, they sold herbs and vegetables. At other times, they sold sweetmeats, seed, candles, and pickles, in addition to gingerbread and a variety of tobacco products. Martha Miksch, daughter of Matthew and Henrietta, worked in the store with her parents. The same room is shown below with a different arrangement of the Moravian furniture from the period that the Miksch family lived in the house. An unusual feature of the house is the absence of windows on the south side.

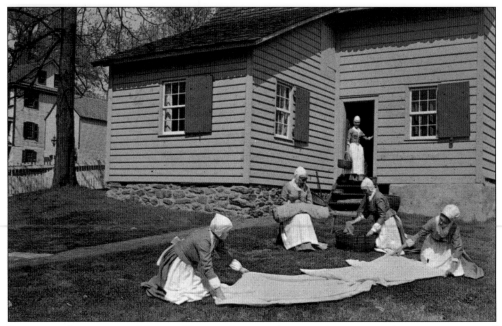

BACK AND SIDE OF THE MIKSCH HOUSE. Costumed women interpreters demonstrate some of the early housekeeping practices on the lawn behind the Miksch House. The Moravian Sisters are spreading out linen to be bleached and dried by the sun. The lean-to addition to the house can be seen above. The photograph below shows the Moravian style of building houses directly on the street, with a fenced yard and the tobacco manufactory behind the house. In addition, a garden occupies an expanse of space behind the manufactory in the very deep lots that accompanied the houses. The Miksch House was later converted for use as a drugstore. In this 1960s postcard, a neon sign can be seen at the center left attached to a building down the street and advertising the first home of Krispy Kreme doughnuts.

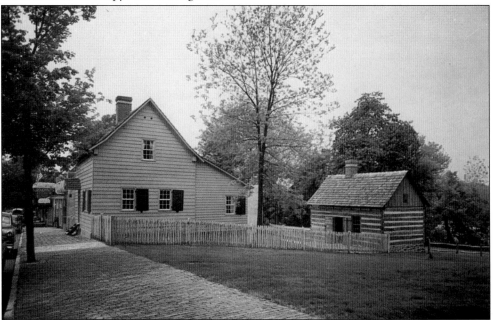

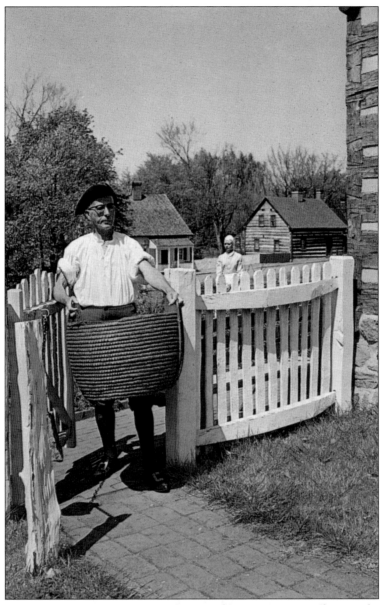

HAGAN HOUSE AND LICK-BONER HOUSE. Costumed interpreters contribute to the experience of touring the historic houses and buildings in Old Salem. Since many homes and buildings have their own gardens, the products of these gardens are often used in various cooking demonstrations. The interpreter seen here is entering a gate from the Miksch House garden. Over his shoulder can be seen two houses on Salt Street, the Hagan House (left) and the Lick-Boner House (right). Francis Hagan lived with his parents in the Hagan House as a child. Being musically talented and a good student, he studied for the ministry and returned to Salem to teach at the Boys' School. During his two-year teaching career in Salem, Hagan wrote the song "The Morning Star," which is often sung at Christmas Eve lovefeasts in Moravian churches. The Lick-Boner House was an early log house built by Martin Lick in 1787 and was later the birthplace of John Henry Boner, a well-known poet and journalist. Earlier residents in the Lick-Boner House were in the salt trade, which gave the street its name.

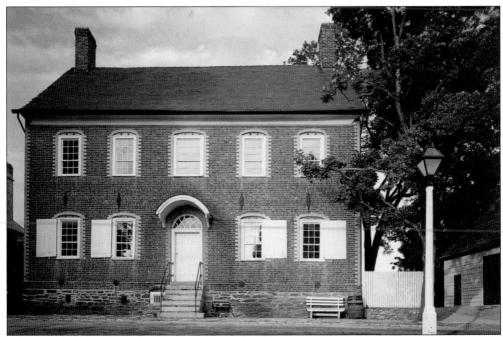

VIERLING HOUSE AND APOTHECARY. The Vierling House (above) fairly glows in the sunshine thanks to the yellow-painted bricks that accent the corners and the windows of the house. Dr. Samuel Benjamin Vierling and wife, Martha, designed their house to accommodate a large family of eight children and his medical practice, including a well-stocked apothecary shop on the first floor. The well-liked physician brought modern medical practices to Salem. Both he and his wife enjoyed and made available to their children such cultural pursuits as music, books, and painting. The large kitchen (below) is furnished with period-appropriate cooking utensils. The 1802 exhibit house is located on Church Street near Bank Street and contains many household items that belonged to the Vierling family. Sadly Dr. Vierling died in 1817 following a typhoid fever epidemic in Salem.

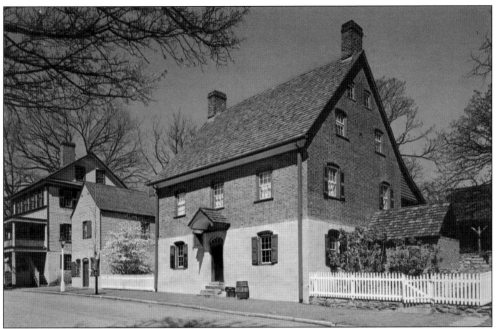

WINKLER BAKERY AND RECIPE. It is easy to find Winkler Bakery in Salem if one follows the signs. The first sign is the aroma of freshly baked bread, sugar cake, and cookies announcing that the bakers have been working for several hours to prepare the oven heated with wood for baking. Brown bags laden with baked goods, some items being sampled from the bags, are signs that the bakery is open and the goods are ready for sale. And an obvious sign is the sheaf of wheat painted on a wooden placard outside of the bakery (above, center) with the name "C. Winkler, Baker." Christian Winkler and his family ran the bakery in Salem until 1926. The recipe card (below), from the files of Louisa Senseman (1822–1854), is for a wedding cake. Louisa was the daughter of John Vogler, Salem's silversmith.

"Wedding Cake + 1# flour, 1# sugar, ¾# butter, 8 or 9 eggs, a nutmeg, a glass of brandy, ½# of currants."

The above recipe is from the manuscript receipt collection of Louisa Senseman (1822-1854), the daughter of Salem silversmith John Vogler. The adaptation below uses modern measurements but keeps the same proportions.

WEDDING CAKE

Cream ¾ lb. very soft butter and 2 C. sugar. Add 8 medium eggs, one at a time, beating after each addition. Mix in 1 grated nutmeg (about 3 tsp.). Add alternately ¼ C. brandy and 3¼ C. all-purpose flour, mixing after each addition. Do not over-beat. Stir in 1½ C. currants. Pour into a greased and floured tube pan. Bake at 350° for 1 hour & 15 minutes. Let cool 10-20 minutes before turning out of pan.

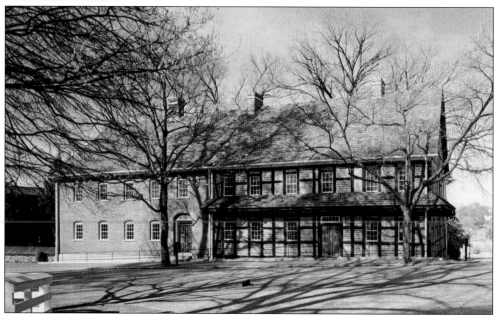

SINGLE BROTHERS' HOUSE. The majority of young men in Salem entered the Single Brothers' House (above) at the age of 14 to live there and to learn a trade. A young man was paired with a master craftsman as an apprentice. The young men who had scholastic leanings were sent to Nazareth, Pennsylvania, to continue their education for becoming ministers, teachers, or business leaders. The Single Brothers lived and worked in this half-timbered house (1769) and in the brick addition (1786) until they married. In later years, the timbered portion of the house was covered in clapboard, which was removed in the restoration. A workshop (below) was built behind the Single Brothers' House in 1771 to give more workspace for their trades. The Single Brothers provided products for Salem households and for commerce.

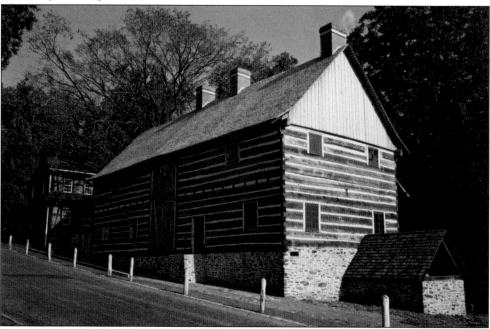

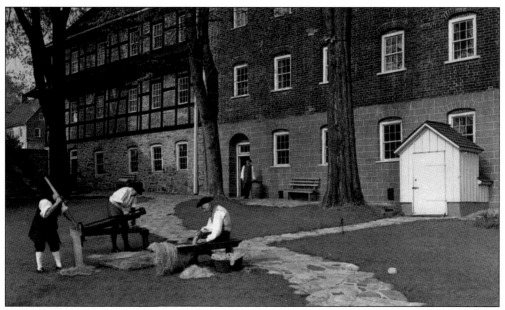

SINGLE BROTHERS' WORK. The importance of the Single Brothers' work in Salem cannot be understated, for much of what was produced and sold in Salem was produced by them. Their crafts included baking, tinsmithing, gun making, cloth and yarn dyeing, weaving, tailoring, pottery making, carpentry, cabinetmaking, and barrel making. Each of these crafts occupied a room in the Single Brothers' House or workshop. Often the men worked outside, as shown in these two postcards, at the back of the Single Brothers' House. The men also operated a brewery, distillery, slaughterhouse, springhouse, woodshed, washhouse, and wagon shed. These businesses were located to the west of Salem. A large terraced garden was planted behind the Single Brothers' House and provided food for the men and the community. The garden has been authentically recreated with plantings that would have been grown during the late 18th century.

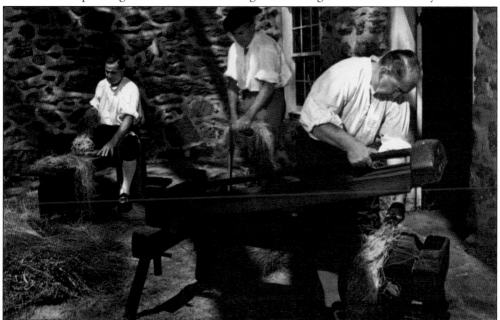

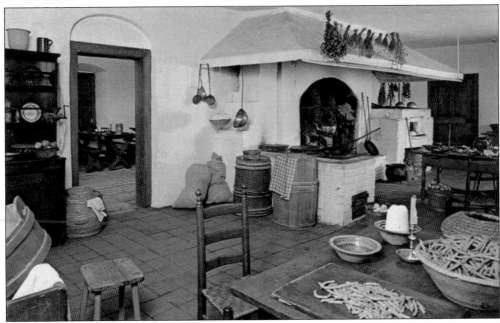

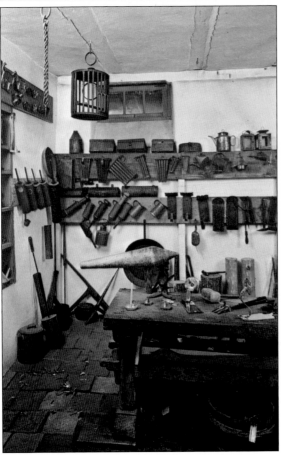

SINGLE BROTHERS' KITCHEN. Providing food and cooking for more than 60 men on a daily basis required a large kitchen and a well-stocked pantry. Cooking was made easier in the new kitchen, which was built in the 1786 brick addition. Located on the ground level next to the dining hall, the kitchen featured a large hooded fireplace, a spit, and bake ovens. Provisions were stored in the cellar and in the attic of the house.

THE TIN SHOP. The Single Brothers did not work with tin and pewter, but a shop was recreated in the Single Brothers' House in Old Salem to show this industry as conducted by the Reich family in Salem. Hanging on the walls are products made by the sheet-metal workers who used hammer and anvil to produce buckets, candleholders, candle molds, sausage stuffers, cookie cutters, funnels, tin boxes, pots and pans, and pipes. (WLB.)

JOHANNES KRAUSE DESK AND BOOKCASE.
Johannes Krause was a talented cabinetmaker
whose furniture could be found in several
Salem homes. This desk and bookcase is
dated 1794–1795 and is made of crotch cherry
veneer and mahogany inlay. Krause employed
an interesting locking mechanism in the
writing portion of the desk that locked all
the case drawers when pushed down. Using
his talent in another venue, Krause also had
a part in the building of Salem's waterworks.
He supervised the route and the laying of the
wooden pipes that brought water to Salem.

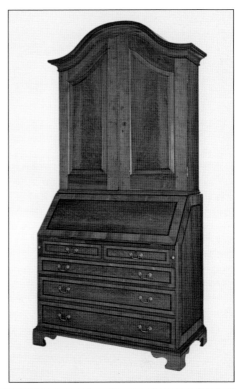

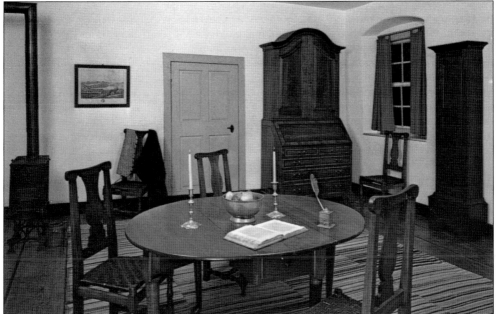

VORSTEHER'S OFFICE. The business manager of the Single Brothers, the vorsteher, lived and
worked in the Vorsteher's Room at the back of the main entrance hall of the Single Brothers'
House. The furniture shown in this room is representative of the era, including the desk and
bookcase built by Brother Johannes Krause, the master joiner. Krause lived and worked in the
Single Brothers' House for his entire career.

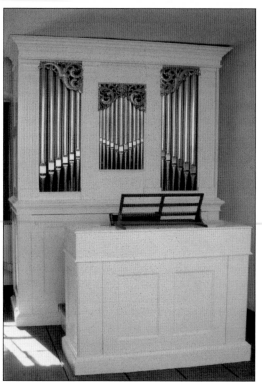

SAAL TANNENBERG ORGAN. Built in 1798 by David Tannenberg, the small one-manual pipe organ was originally used in the Gemein Haus (Congregation House) before Home Moravian Church was built. The organ was kept in storage for almost 100 years before being restored in 1964 and installed in the Single Brothers' House. The organ underwent another restoration in 2008 by Taylor and Boody, with the main focus to return all of the original pipes to the organ. Additionally, new stop knobs were added, and the organ case was painted white.

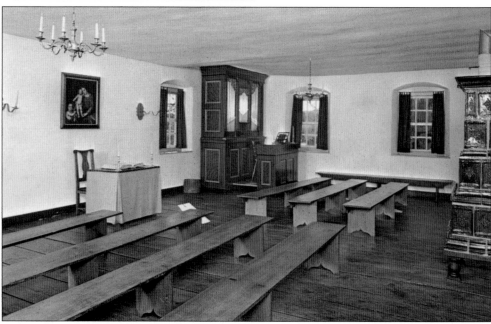

SINGLE BROTHERS' SAAL. The Saal, or meeting room, is located in the 1786 brick addition. This room was used for Bible reading, singing, and prayer on a daily basis. It was also used for special services, such as lovefeasts, music rehearsals, and meetings. The room was sparsely furnished with benches, the organ, and a stove. The Candle Tea takes place here each December, with the organist playing Christmas carols for a sing-along.

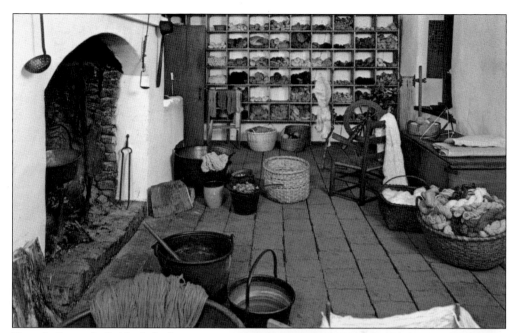

DYER'S SHOP. Individuals had to send their cloth to Bethlehem, Pennsylvania, to be dyed or tackle the job at home. The first professional dyer came to Salem in 1774 but left two years later. When the 1786 brick addition was built for the Single Brothers' House, it provided a new kitchen. The former kitchen was turned into a dye shop, where yarn was dyed by natural processes.

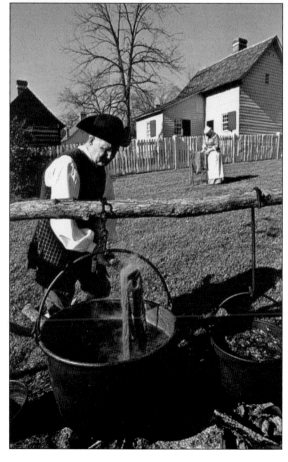

WOOL DYEING DEMONSTRATION. The dyer's shop was often called the blue dyer's shop because the blue of indigo was a popular color for dyed goods. Indigo was imported from the Charleston area, and a brass pot with this liquid was kept simmering in the shop. Because it was a foul-smelling liquid, it was preferable to work with it outside over an open fire. Dyeing goods was always a challenge, because one bath was rarely duplicated, making it difficult to produce matching batches of yarn.

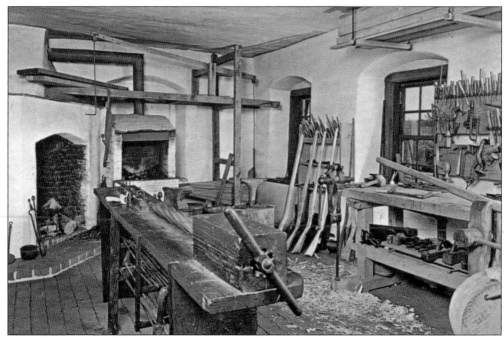

THE GUN SHOP. Several gunsmiths worked at different times in Salem in their own shops, except for the days during the American Revolution when guns, ammunition, and any signs of gunsmithing were hidden. During these war years, the gunsmith moved to the Single Brothers' House and made less volatile wares, such as nails and locks. The shop shown in the postcard demonstrates the process of long rifle manufacturing. (SMM.)

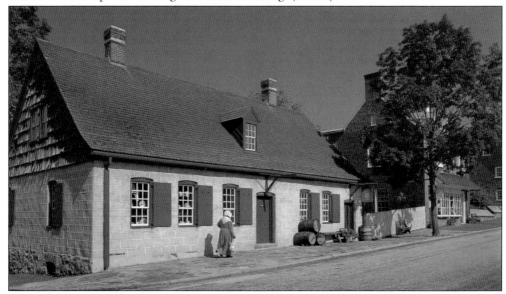

T. BAGGE: MERCHANT (COMMUNITY STORE). Built in 1775, the Community Store (left) at 626 South Main Street carried all the essentials that would be found in a town's general store. Brother Traugott Bagge was the proprietor of the Community Store and took a personal interest in procuring first-rate goods for the store and for the people of Salem. T. Bagge: Merchant is operated by Old Salem Museums and Gardens and offers fine reproductions and gift items.

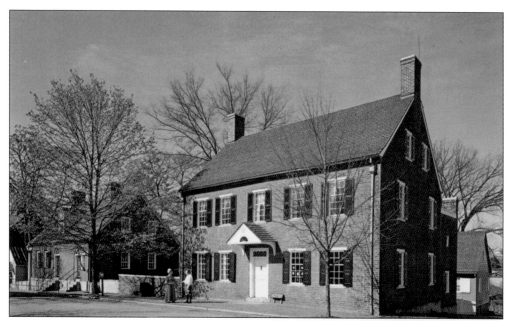

JOHN VOGLER HOUSE. John Vogler built the impressive brick house at right on the corner of Main and West Streets in 1819 following his marriage to Christina Spach. His uncle, the gunsmith Christoph Vogler, lived in the house to the left. An interesting exterior feature of the John Vogler House is the pediment over the front door showing a painted clock face (his trademark) and a decorative fan of glass.

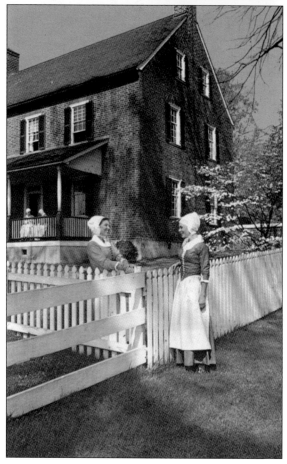

BACK OF THE JOHN VOGLER HOUSE. The Vogler House entails many innovative building designs that have been attributed to John Vogler's talent as an artist. Built in the Federal style, the house's interior arrangement is a central-hall, four-room plan. Examples of Brother Vogler's talent as a silversmith, clock maker, and silhouettist can be seen throughout the exhibit house.

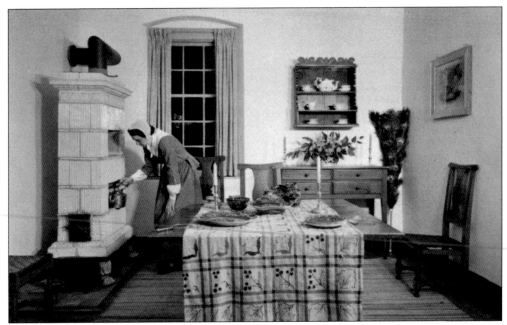

VOGLER HOUSE DINING ROOM. The postcards above and below show the John Vogler House dining room with slightly different furniture. One of the main features in the room is the tall yellow-tile stove against the wall. The tiles stoves were preferred in Moravian homes and other buildings, such as the Girls' School, because there was less chance of fire, and the stoves provided more constant heat. In January 1955, the Vogler House had two special visitors, Mary Pickford and her husband, Buddy Rogers. During their tour, they expressed great interest in the restoration effort of Old Salem. Looking at the furniture in the house, Mary Pickford commented, "I believe we're bigger today than people used to be." Her comment brought smiles to the group, for she was just 5 feet, 3/4 inches tall.

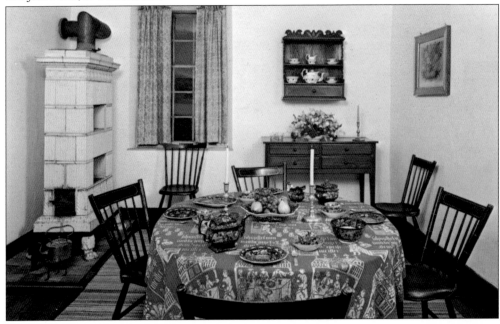

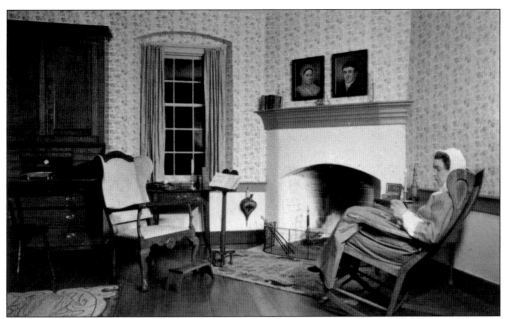

VOGLER HOUSE PARLOR AND KITCHEN. Portraits of John and Christina Spach Vogler hang over the fireplace in the parlor above. Vogler requested permission to marry Sister Spach but was denied by the lot system. He continued to proffer candidates for marriage but was denied each time. Finally, the lot system for making these decisions was abandoned, and John was able to marry Christina in 1819. They were married for 44 years, and John Vogler lived to the age of 97. Three children were born to the couple, Lisetta, Louisa, and Elias. The children were well educated, well traveled, and encouraged to pursue their artistic inclinations. Over 50 descendants of John and Christina Vogler attended the opening ceremonies of the restored house in April 1955. The house was given to Old Salem by Pauline Bahnson Gray, and other descendants contributed to the preservation effort.

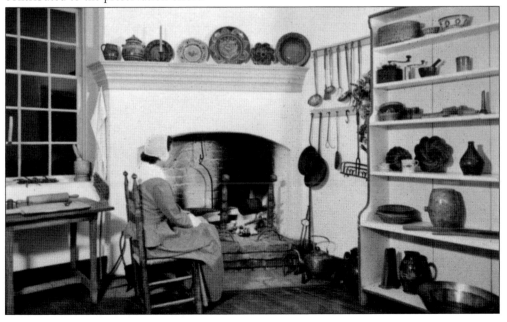

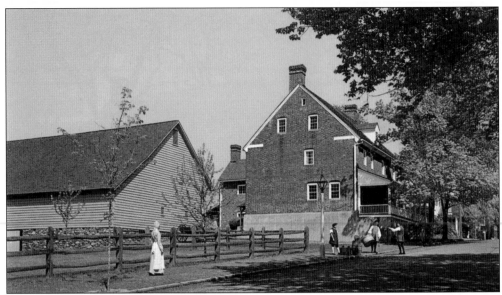

SALEM TAVERN, BARN, AND DINING ROOMS. Donated to the Wachovia Historical Society in 1941, the restored tavern building (above, at right) is interpreted to the year 1791, when George Washington made his famous visit to Salem. The tavern owned land that was planted with crops to supply food for the guests. The area beside the tavern contained a barn, a stable, a cowshed, a necessary (toilet), a woodshed, a smokehouse, and later a washhouse. The yellow barn (above, at left) that sits on the property today was moved to Salem from the Beverly Jones farm near Bethania in 1961 but dates at least from the 1840s. Costumed waiters serve guests in the Salem Tavern Dining Rooms (below), which opened in 1969. A large foyer opens to rooms on two levels where guests are served on bare wooden tables, often illuminated by candlelight.

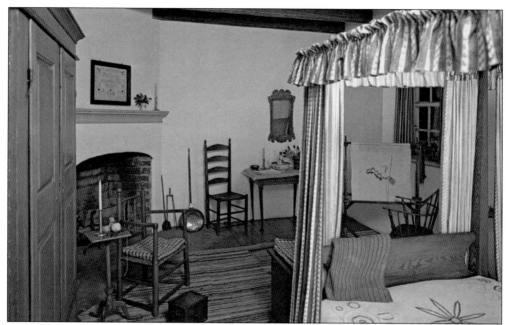

TAVERN KEEPER'S BEDROOM. The tavern was operated by a Moravian couple who lived and worked in the tavern. The restored bedroom features furniture typical of the period, and some of the needlework of the Salem women is shown on the bedcovering and on an embroidery frame. Visitors touring the tavern can also see the window where a traveler inscribed a name and the date March 10, 1813, into the glass.

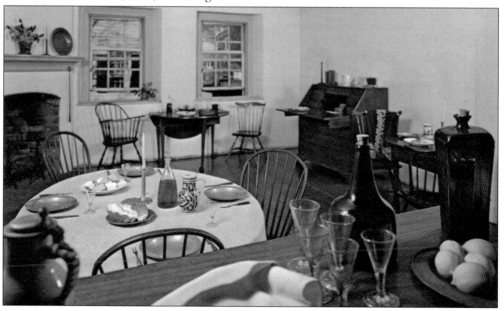

TAVERN GENTLEMEN'S ROOM. Tavern guests were served in the two front rooms in the 1784 tavern. In the Guest Room to the left could be found the everyday travelers who shared the ordinary fare together at long tables. Across the hall was the Gentlemen's Room, shown here, which offered more privacy and comfort, and the food was more elaborate. The tavern's windowless front facade discouraged curious Salem residents from witnessing unacceptable behavior.

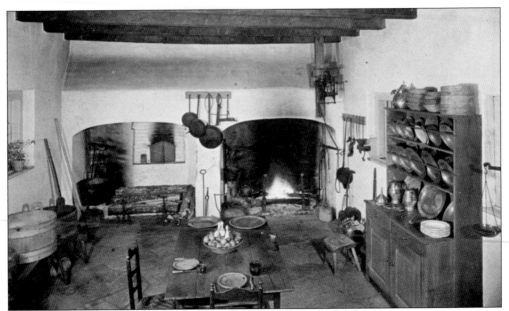

TAVERN KITCHEN. The flagstone-paved kitchen was the heart of the tavern with its two large open fireplaces and a weight-operated spit for roasting meat. The collection of kitchen implements and the furniture in the room give a realistic look of a tavern kitchen at the end of the 18th century. The bake oven and dry shed, also part of the kitchen, were located at the rear of the tavern. (WLB.)

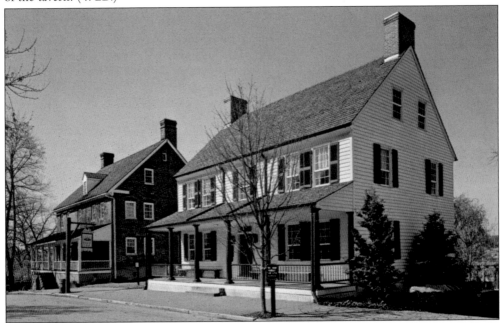

SALEM TAVERN AND DINING ROOMS. An unattached tavern annex (right) was built in 1816 as a lodging house, where no meals were served. A dining hall was built in 1832 that connected the tavern (left) and annex, and then a two-story porch was built across the facade of all three buildings. The dining hall was removed, and today the annex houses a restaurant where diners can sample Moravian chicken pie and other Old World cuisine.

MORAVIAN BOOK AND GIFT SHOP. The building (right) at 614 South Main Street once housed the Old Salem Reception Center and was also the Arden Farm Store; earlier it was called the Elias Vogler Store. Moravian Book and Gift Shop occupied the building in the late 1970s, first operated by the Moravian Church and currently by Old Salem Museums and Gardens. The shop carries a variety of specialty gift items, including local books.

SALEM ART SISTERS. The bond of sisterhood can come from bloodlines or from a common interest that women share. The Salem Art Sisters paint, take classes, travel, and exhibit their work together in local galleries (such as Allegacy Credit Union's Keener Gallery) and in retail locations. The women rented space in the Moravian Book and Gift Shop in 2007 where they paint and display their artwork, often inviting the public to visit.

49

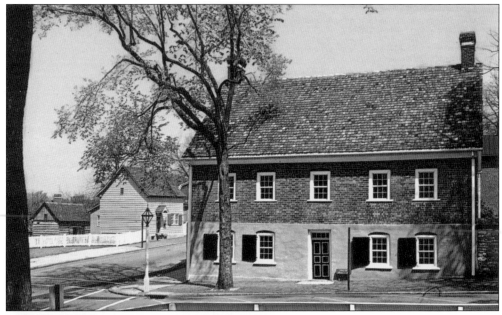

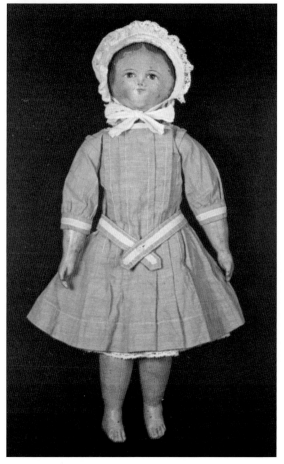

SALEM BOYS' SCHOOL. Located on the corner of Main and Academy Streets, the Boys' School (right) opened in 1794 for 6- to 14-year-old boys. A new Boys' School was built in 1896 on the corner of Church and Bank Streets, leaving the building vacant. It was then used as the home of the Wachovia Historical Society. Renovations to the Boys' School began in 2009 to provide additional uses for the building.

PAINTED CLOTH DOLL. The daughters of Christian Thomas and Margaret Siewers Pfohl made painted cloth dolls, which were popular among Salem girls at the beginning of the 20th century. Margaret Gertrude (Maggie) and Caroline Elizabeth (Bessie) Pfohl lived on South Main Street. Their dolls were made in two sizes, with this doll measuring almost 14 inches tall. The dolls, along with other Salem toys, were exhibited in the Wachovia Museum, which contained many historical objects owned by the Wachovia Historical Society.

WACHOVIA MUSEUM. Costumed interpreters stand on the corner of Main and Academy Streets in front of the Boys' School, later called the Wachovia Museum. The Wachovia Historical Society was formed in 1895, and in addition to preserving valuable historical artifacts, it began to offer a "Tour of Old Salem with Guide" for $1 per group in 1938. The society also planted the seeds of a historical reconstruction for Salem.

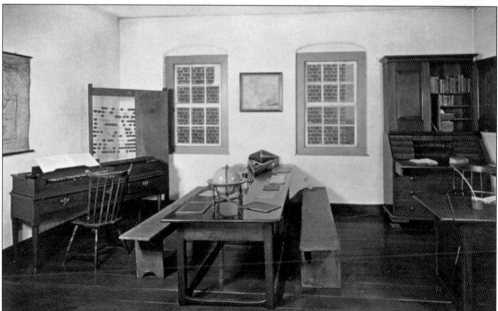

BOYS' SCHOOL CLASSROOM. The rigorous academic regimen in the school was combined with strict discipline, all in the Germanic tradition. The boys were also expected to exercise and play outside but were not permitted to be noisy or disturb others in the vicinity of the school. Items in the classroom are an abacus in the corner, slates on the desk for writing, a globe, and benches at the long desk.

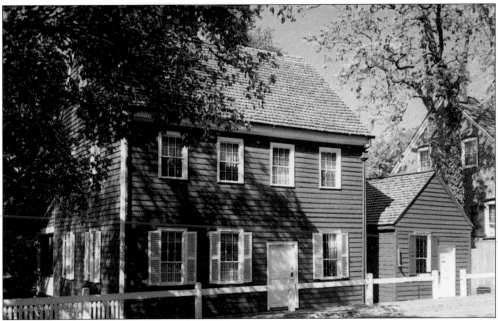

SHULTZ HOUSE AND SHOEMAKER SHOP. Samuel Shultz was one of several shoemakers in Salem and worked his trade in the Single Brothers' House until he married Christina Hein and built his home on South Main Street in 1819. The two-story frame house (above at left and below) also contained his workshop until he built a separate but matching building for a shop in 1827 (above, right). Additions were made to the shop twice over the years, but these were removed during restoration in 1978. One of five original shops surviving in Salem, the one-room shop features a freestanding exterior chimney on the west end of the building. Shultz also fashioned leather fire buckets, breeches, and boots, all made in the shop under the sign of the wooden boot. Today costumed interpreters demonstrate the shoemaking trade using tools and methods from the early 19th century.

SALEM COFFEE POT, 1914. Some people consider the pineapple a symbol of hospitality. But in Winston-Salem, the symbol of hospitality is an imposing metal coffee pot with a handle, lid, and spout. In 1914, the Coffee Pot was 56 years old, and it stood on a wooden post at the corner of Main and Belews Street. It was built originally by Samuel and Julius Mickey to make their tin shop more distinguishable from their competitors. (SMM.)

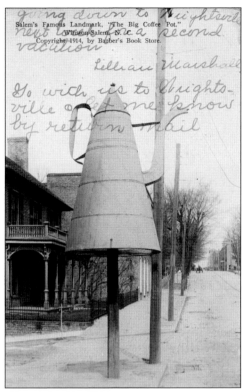

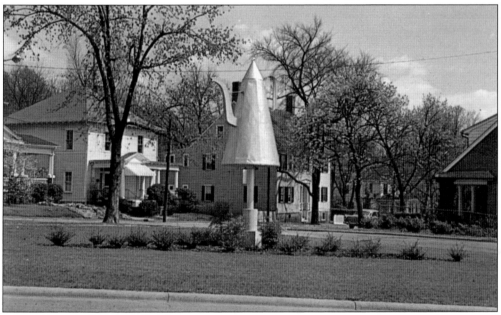

RELOCATED SALEM COFFEE POT. As Interstate 40 construction advanced toward the center of town with the Coffee Pot directly in its path, concern arose regarding a future home for the city's landmark. In 1959, the Coffee Pot was removed from its previous base and trucked down South Main Street to a grassy triangle, where it continues to remind passersby of the city's industrious Moravian heritage and of Winston-Salem's commitment to hospitality.

ANNA CATHARINA HOUSE. The drawing of the Anna Catharina House, seen above, shows the first house in Salem to be built with a timber frame. Constructed by surveyor Philip Reuter, the second husband of Anna Catharina, the house was originally situated on the corner of Main and West Streets. Anna Catharina was married four times and outlived each of her husbands. Adelaide Fries wrote the book *The Road to Salem* as a fictionalized memoir based on the life of Anna Catharina. After she died in 1816, John Vogler bought Anna Catharina's house and moved it to the back of the lot, where John and his wife lived while their new house was being built. Later, the house was used as an outbuilding and a carriage house. The historic house is shown in the background below between the two larger Vogler houses. (Above, SV.)

Belo House. Edward Belo built his impressive home on Main Street in 1849 with his store located on the first floor. The decorative ironwork was cast in Belo's foundry, including the animal statues on the Bank Street side of the house. The women living in the Widow's House (formerly the Single Brothers' House) moved to the Belo House, which was converted to apartments in 1960 so that the Single Brothers' House could be restored.

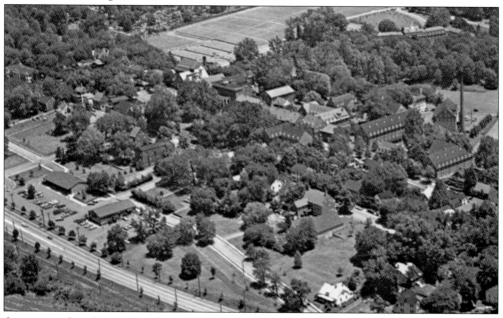

Aerial of Old Salem and Salem College. This view of Salem and Salem College from the south shows many of the restored houses and the highway that was built to bypass the historical area. Between the bypass and Main Street (center left) are two buildings, one of which was the visitor's center, and the other, perpendicular to the first, which housed the post office and a Mayberry's Restaurant.

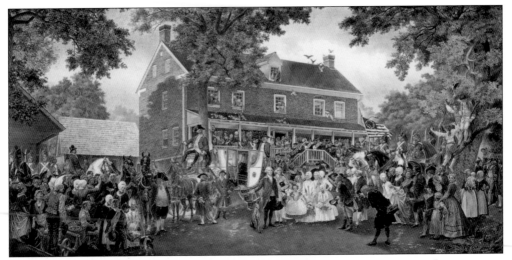

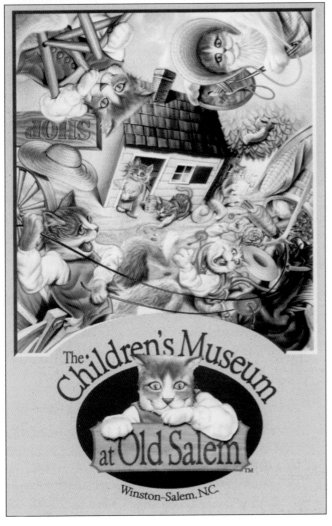

SALEM TAVERN PAINTING. Pres. George Washington made a historic visit to Salem on May 31, 1791. The excitement of the Salem residents and the festiveness of the occasion are captured by Werner Willis in his painting titled *Washington's Southern Tour; Old Salem's Presidential Reception, May 31, 1791.* The original watercolor painting measures approximately 3 feet by 6 feet. In May 2005, Willis signed copies of prints made from the original painting at the Moravian Book and Gift Shop. (WW.)

CHILDREN'S MUSEUM AT OLD SALEM. Before the Children's Museum of Winston-Salem was built on South Marshall Street, there was a children's museum in the Frank L. Horton Museum Center in Old Salem. Children between the ages of four and nine could experience life as a child in Salem with hands-on activities geared to their ages. The cat on the postcard is Herr Kater, an imaginary Salem cat.

MESDA. The Museum of Early Southern Decorative Arts (MESDA) opened in 1965, established through the efforts of Frank L. Horton and his mother, Theo Taliaferro. They shared a vision of forming a unique museum that would preserve, document, exhibit, and interpret the decorative arts of the early South. Today MESDA is a museum and a research center that can document Southern artists, artisans, and craftsmen and Southern-made objects.

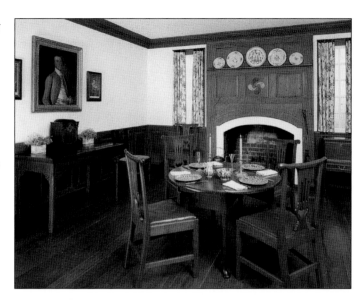

OLD SALEM TOY MUSEUM. Children in Salem played with toys that were homemade, fashioned by local craftsmen, or imported from Germany. Many of these toys and their histories survive from the 18th and 19th centuries. Thomas A. Gray and his mother, Anne Pepper Gray, amassed a world-class toy collection (example seen here) that they donated to Old Salem. The two toy collections united in 2002 to become the Old Salem Toy Museum.

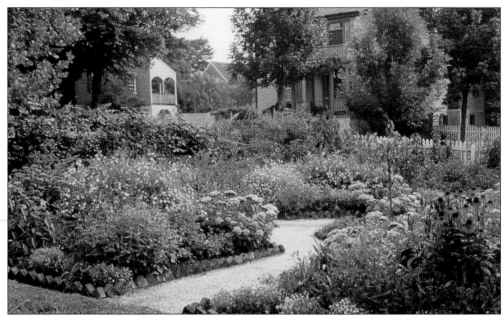

OLD SALEM GARDENS. While Salem was not planned as an agricultural community, the inclusion of a garden for each household was important for the family's livelihood. Each householder's lot consisted of a house, a yard, and a garden. The yards were packed soil, which was swept clean, and beyond the yards were the gardens that provided food for the household. In fact, many households owned a lot outside of the town for growing larger field crops and for keeping cattle. The family gardens were laid out in squares, bordered with sod, and divided by paths. Flowers, herbs, and vegetables were often planted together. The yard and garden were usually fenced for privacy and to keep children in the yard and animals out of the garden. Shown here are the gardens of the John Siewers House (above) and the John Henry Leinbach House (below).

Three

Home Moravian Church and Salem Moravian Graveyard

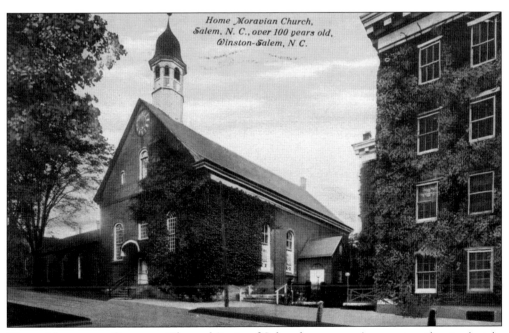

Home Moravian Church. The architects of Salem began a major construction project in 1770 to build the Gemein Haus or the Congregation House. This building held the Gemein Saal or hall, living quarters for the minister and his family, quarters for visiting dignitaries, and space for storing musical instruments and archival records. The Gemein Haus was replaced by Main Hall (right) in 1856. Home Moravian Church (center) was built in 1800, just north of the original Congregation House.

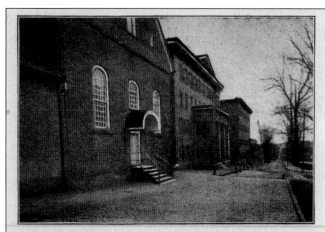

Salem, N. C.,

MORAVIAN CHURCH AND
SALEM ACADEMY AND COLLEGE.

HOME MORAVIAN CHURCH ON A PRIVATE MAILING CARD. An act of Congress in 1898 authorized private printers to make and sell private mailing cards. The name was printed on the back of cards and distinguished them from government-printed cards. The era of the private mailing cards was from 1898 to 1901, when postal regulations changed to allow private printers to use "postcard" on their products. The view of Church Street, from Home Moravian Church looking south, is a private mailing card, and the images show the front (above) and the back (below) of the card. The front was for the image, with room on the side or at the bottom for a message. The back was only for the address. The practice of using the back of the card only for the address continued until 1907. (Both, SV.)

Private Mailing Card.

PLACE THE
POSTAGE STAMP
HERE

AUTHORIZED BY ACT OF CONGRESS · MAY 19. 1898.
(POSTAL CARD – CARTE POSTALE.)

THIS SIDE FOR THE ADDRESS ONLY.

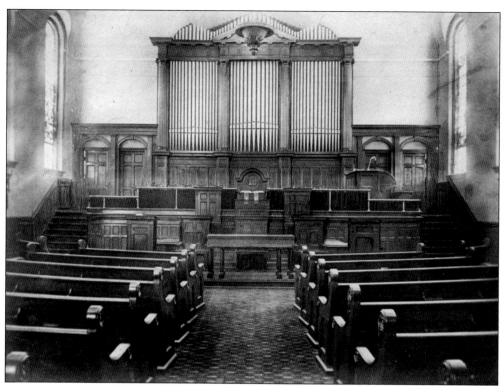

HOME MORAVIAN CHURCH INTERIOR, 1913. Major renovations were made to the sanctuary interior in 1870, 1913, and 1959. In 2009, a $1.9-million renovation revealed intricately detailed wood floors that were installed in 1913 but were covered with carpet for many years. Wheat-colored walls, refinished pews, a new heating and air-conditioning system, new lighting and audio/video systems, a renovated organ console, and a restored organ gave a new look and feel to the historic church. (MA.)

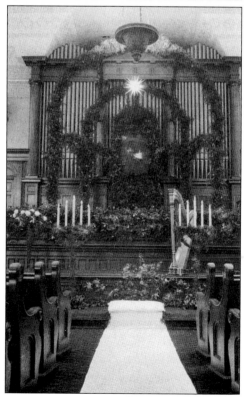

HOME MORAVIAN CHURCH INTERIOR, 1928. The church was festively decorated for Christmas, with greenery, white tapers, and a star providing the perfect background for a wedding. Mary Dorothea Pfohl, daughter of Home Moravian pastor J. Kenneth Pfohl, married Dr. Vernon Clark Lassiter on December 22, 1928. The bride's sister Ruth played the harp, while their mother, Bessie, provided a musical program at the organ. The white runner led to a kneeling bench of 1892 vintage. Dr. Lassiter was a resident physician at City Memorial Hospital, where his bride worked as a nurse. (MA.)

HOME MORAVIAN CHURCH BELFRY. High above the church is the original weather vane sporting the date 1800, which designates the year that the church was completed. Acanthus leaves top the finial of the weather vane, and a gilded ball sits atop the white cupola. Fitted into the west gable is the clock, which marks the time on the quarter hour. The clock predates the church and was purchased in Europe. It sat on a platform with the bell in Salem Square before it was installed in the church.

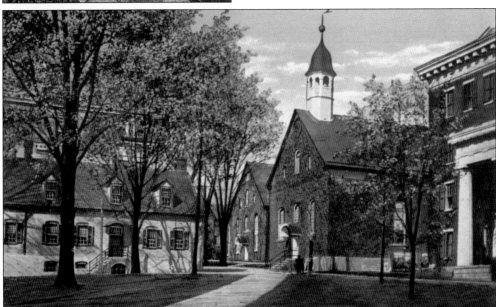

HOME MORAVIAN CHURCH, 1937. Bishop Edward Rondthaler served the Salem Congregation as pastor for 53 years. During these years, he witnessed the growth of Winston-Salem and recorded his observations in the *Memorabilia*, which he read every New Year's Eve in Home Moravian Church. This view of Salem Square at Academy and Church Streets shows the Rondthaler Memorial Building (center), which replaced the chapel to the north of the church.

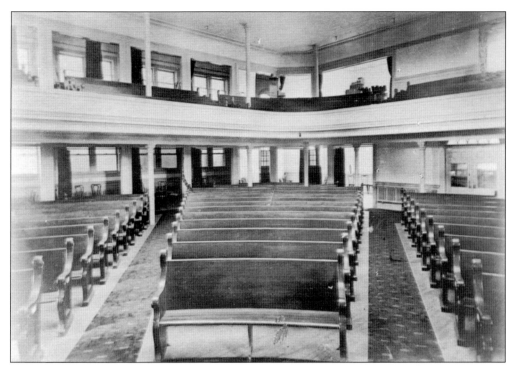

RONDTHALER MEMORIAL BUILDING. The years 1912 and 1913 brought a new look to the area around Home Moravian Church. Young Edward Rondthaler and J. Kenneth Pfohl Jr. broke ground for the Rondthaler Memorial Sunday School Building on June 8, 1912. Named in honor of Bishop Edward Rondthaler, the first services in the new building were held on June 15, 1913. The postcards above and below show the building interior from the front and from the back of the building. The bottom floor is an immense auditorium with seats arranged in semicircles and the rostrum located in the northeast corner of the room. Classrooms circle the auditorium. There is an upper story of classrooms that open out upon a gallery that extends entirely around the room. The interior is painted white. A newspaper article reporting on the new building commented, "This is a house erected for service." (Both, MA.)

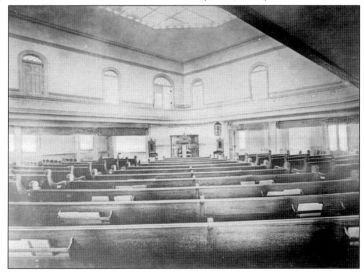

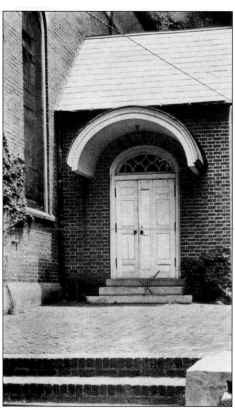

DOORWAY OF HOME MORAVIAN CHURCH. The "Moravian Hood" is a term well understood in Winston-Salem, as this arched hood covers Moravian church doorways and the doorways of some homes and businesses in town. The arched hood was an architectural innovation designed by Frederic William Marshall for the main entrance of Home Moravian Church. The arched hood was added to this side doorway of the church at a later date.

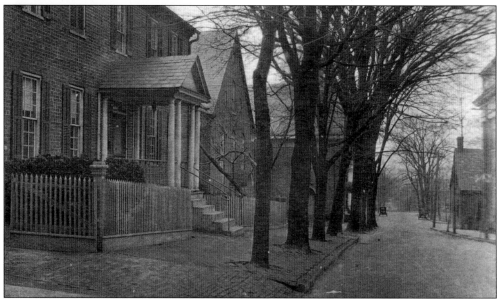

THE BISHOP'S HOUSE. Bishop William Henry Van Vleck and his family moved into the new parsonage (left) on Church Street in 1841. The new house was built as the result of an agreement whereby the Gemein Haus, or Congregation House, was turned over to the Girls' Boarding School in exchange for building a new house for the pastor, who previously lived in the Gemein Haus. A new chapel was also included in the agreement.

GALLERY ON HOME MORAVIAN CHURCH.
The original wooden gallery was built
in 1804 on the west gable of the church,
about 35 feet above the street. Band
members would come through the door
behind the gallery and musically announce
festive occasions and sad occasions, such
as deaths and funerals. The occasion
could be discerned by the type of hymn
played by the band. The original gallery
was removed in 1836, not to be replaced
until 1966 when steel beams were used
for added strength and longevity.

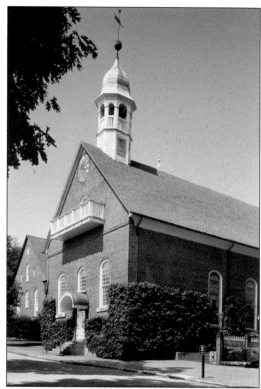

**SALEM BAND AT COURTHOUSE
SQUARE, 1905.** Worship services and
music are synonymous in Moravian
churches, even from the very early days
of Moravian settlement in Wachovia.
The first musical instruments used
in Salem were trombones that came
from Bethabara. The Salem Band
performed for many events and special
occasions, such as the dedication of the
Confederate Monument on Courthouse
Square in 1905, shown here. (MA.)

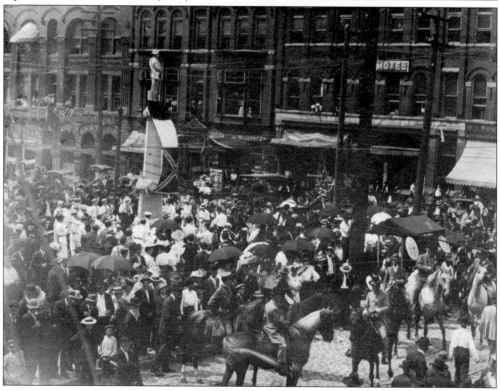

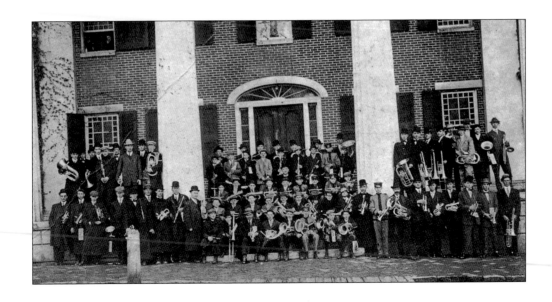

MORAVIAN CHURCH BAND. The history of the Salem Band details the ups and downs of organizing and training band members throughout nearly two and a half centuries. Dedicated musicians and leaders participated in concerts, festivals, funerals, Easter services, parades, anniversaries, and tournaments. The Easter band began with 6 or 8 players but had increased to 50 in 1910 and 79 when the photograph was taken of the band in front of Main Hall in 1911 (above). Bernard J. Pfohl directed the Salem Band for 50 years, retiring in 1947. He conducted many Easter bands during that time, and even then the participation of several generations in a family was noted. The Salem Band often played for citywide events, such as the Firemen's Association Tournament in 1914. The band members shown below are seated on the steps of Main Hall. (Below, OSMG.)

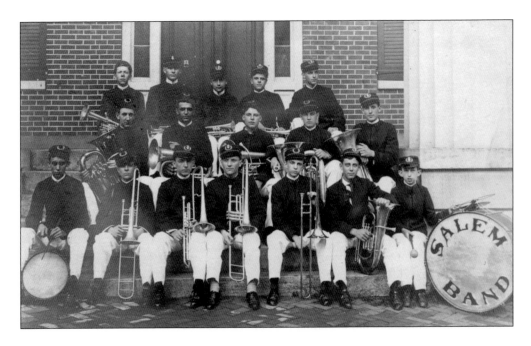

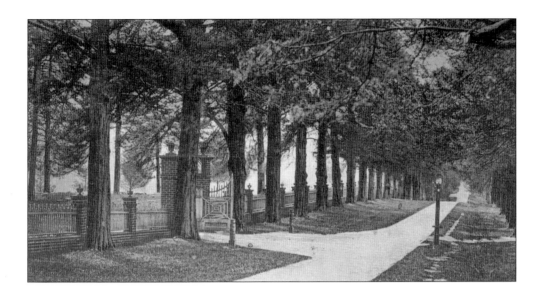

CEDAR AVENUE AND GOD'S ACRE. The lane that connects Cemetery Street to Church Street and runs beside God's Acre (above) was named in recognition of the cedar trees that were planted in the late 18th century and lined the avenue until they were removed in 1918. Darlington oak trees replaced the cedars, but these trees were damaged in the May 1989 storm that hit Old Salem and caused damage in many parts of Winston-Salem. Holly and cedar trees replaced the damaged oaks and have a bit of growing to do before they create the canopy of branches over the avenue that is shown in the above postcard. The postcard below shows God's Acre on an Easter Sunday, with the graves decorated with colorful flowers being visited by family members and city residents, as has been the tradition for many years.

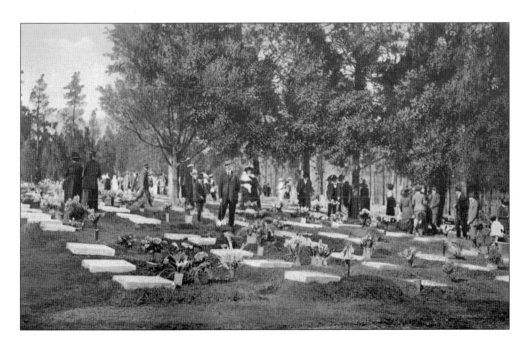

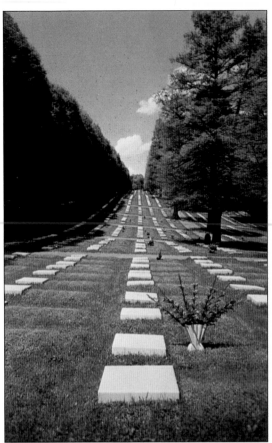

GOD'S ACRE IN SALEM. God's Acre is the name for the burial ground of a Moravian church. It was thought of as God's field, where the bodies of believers are sown awaiting the Resurrection. The graveyard is divided into sections where church members are buried according to their "choir," which was a group within the congregation made up of individuals of similar life circumstances, such as Single Sisters, Single Brothers, Married Sisters, Married Brothers, boys, and girls. Burial plots are marked with the white recumbent stones, symbolizing a person's equality in death.

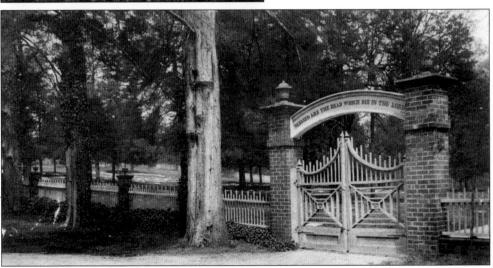

"BLESSED ARE THE DEAD WHICH DIE IN THE LORD." Salem's graveyard and Cedar Avenue were laid out in 1770, with the first burial taking place in 1771. This postcard shows one of five different gates to the graveyard, each marked with a Bible verse on both sides of the arch above the gate. The tradition of adding an inscription began in 1834 in Salem but had its origins in European Moravian graveyards.

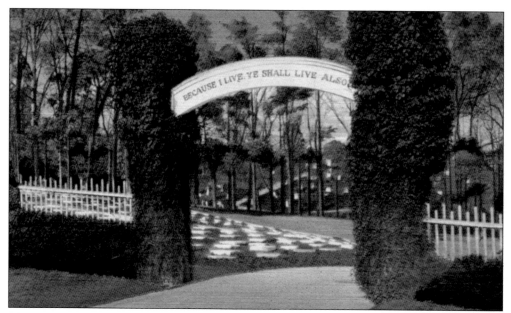

"Because I Live, Ye Shall Live Also." The white stones on the graves are cleaned and adorned with flowers, particularly at Easter, when the sunrise service takes place in God's Acre. Salem's first Easter morning service was held in 1771, but not in God's Acre. The graveyard had not been consecrated with a burial, although this occurred just three months later. The first outdoor service, concluding at the graveyard, was held in 1773.

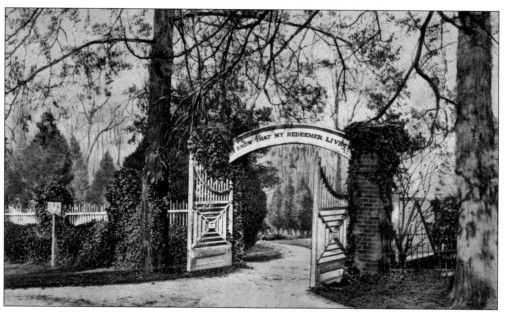

"I Know that My Redeemer Liveth." On Easter Sunday morning, services are held outside of Home Moravian Church, with the minister announcing, "The Lord is risen," and the congregation responding, "The Lord is risen indeed!" After a brief service, the Easter band leads the congregation down Cedar Avenue to conclude the simple but beautiful and reverent sunrise service. This gate to the graveyard is the closest to Home Moravian Church. (WLB.)

69

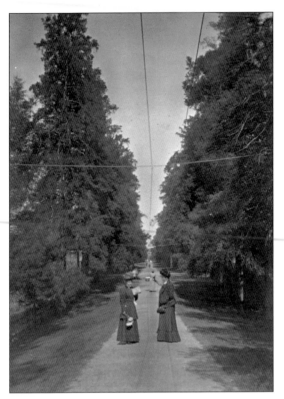

WOMEN ON CEDAR AVENUE. The postcard is inscribed, "Ruth and Mother Thaeler," and "Valentine Greeting!" is written on the back. The women are thought to be Ruth Carolina Schropp Thaeler (left) and her mother-in-law, Marie Louise Gruhl Thaeler. Ruth married Arthur David Thaeler in 1894 during the time that he was assistant pastor of Salem Congregation and pastor of Calvary Moravian Church. Ruth and Arthur had five children and moved to Bethlehem, Pennsylvania, in 1901. (MA.)

EASTER SUNRISE SERVICE. The service at Home Moravian Church was broadcast on two local radio stations and was also broadcast on shortwave through Columbia Broadcasting System. The smaller crowds attending the 1943 service and the presence of women playing in the Easter band were a reminder of the wartime changes. At the conclusion of the litany service, Bishop J. Kenneth Pfohl addressed a message of inspiration and encouragement to the "Armed Forces of America, everywhere in the air, on land and sea, and under the sea."

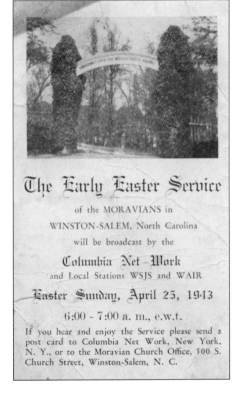

The Early Easter Service

of the MORAVIANS in

WINSTON-SALEM, North Carolina

will be broadcast by the

Columbia Net-Work

and Local Stations WSJS and WAIR

Easter Sunday, April 25, 1943

6:00 - 7:00 a. m., e.w.t.

If you hear and enjoy the Service please send a post card to Columbia Net Work, New York, N. Y., or to the Moravian Church Office, 500 S. Church Street, Winston-Salem, N. C.

Four

SALEM ACADEMY AND COLLEGE

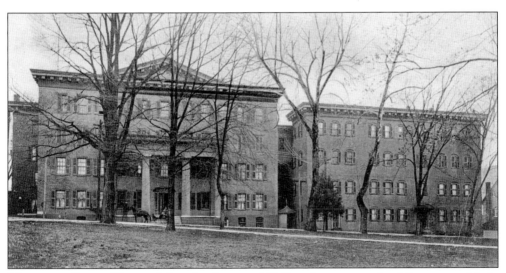

MAIN AND SOUTH HALLS. Salem Academy and College began as a school for young girls in 1772 in the Gemein Haus. Just a few years later, a boarding school was established, and South Hall (right) was built for that purpose. When the school outgrew the Gemein Haus, Main Hall (left) was built in its place. Salem College still occupies these buildings as the oldest continuing educational institution for women in its original location in the United States. (WHS.)

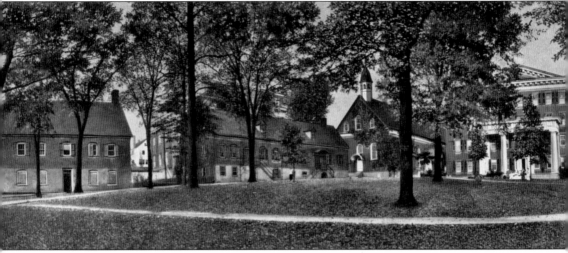

PANORAMA OF SALEM ACADEMY AND COLLEGE. Standing on South Main Street facing Salem Square, this is the view from left to right that encompasses buildings in Old Salem, including those of Salem College. From the Boys' School on the far left to the Bagge House on the far right, each building has a place in the history of Old Salem and Salem College. Shown on the left are the Boys' School, the Inspectors' House, Home Moravian Church, and Main Hall. The

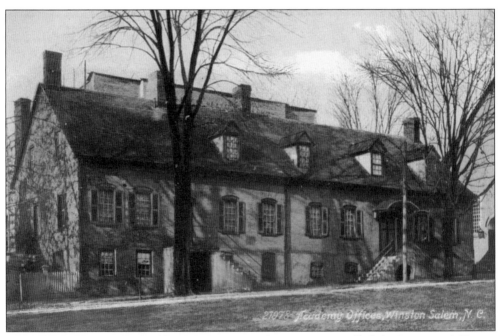

ACADEMY OFFICES. The building at 11 East Academy Street is called the Inspectors' House, which is another term meaning headmaster. The original building (right) was constructed in 1811, with the same arched hood seen today over the doorway. The office of Salem College's president occupies the original building. The Salem College Bookstore is housed in the sections added in 1838 and 1850, seen on the left.

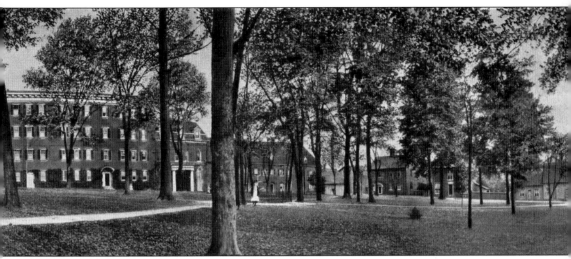

buildings from the far right to the center are the Bagge House, the Shober House, the Single Sisters' House, West Gate Hall, and South Hall. A decorative fence encircles a fountain in the center of Salem Square, and a woman passes by the fence on a path. The right side of the panorama has changed more than the left, with the removal of West Gate Hall and the addition of the Salem Library behind the restored Shober House.

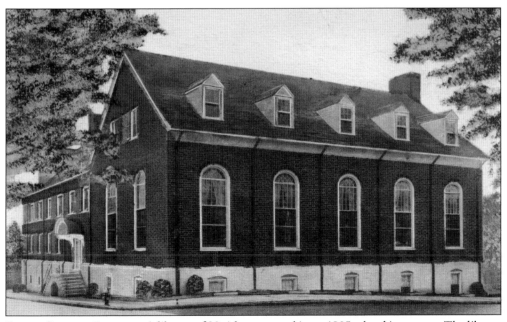

SALEM COLLEGE LIBRARY. A library of 23 titles appeared in an 1805 school inventory. The library was housed in South and Main Halls and the Old Chapel until a new library was occupied in 1938 on the corner of Church and West Streets. The library needed more room, and Old Salem wished to reconstruct the Shober House at this location, so in 1972 the library was lifted from its foundation and rolled 90 feet south to its current location and enlarged.

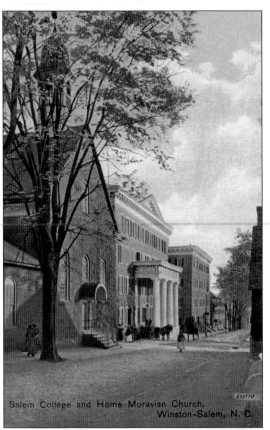

EARLY VIEW OF CHURCH STREET. The 17 Single Sisters and four Older Girls who came to Salem in 1772 moved into the newly built Gemein Haus. They occupied the south end of the building and shared the facility with the ministers and their wives. A few weeks later, Sister Elisabeth Oesterlein was chosen to teach three little girls in a schoolroom of the Gemein Haus. The school had grown to seven pupils in 1774, thus forming the foundation of the educational institution known today as Salem Academy and College.

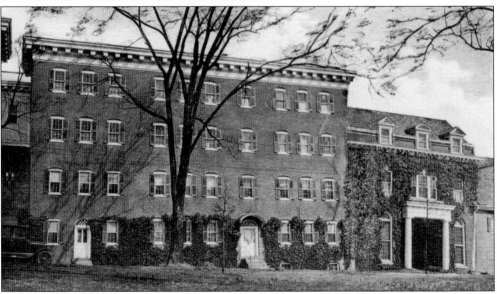

SOUTH HALL. As the first building constructed for the Girls' Boarding School, South Hall (left) opened in 1805. The original building had a steep roof with dormer windows. An addition was made to the north side in 1824, containing classrooms and the first chapel. The roof was removed and two stories were added in 1873, making South Hall similar in appearance to Main Hall.

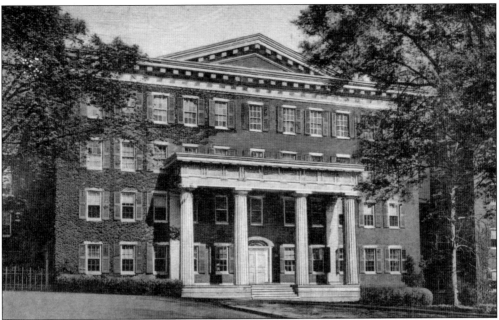

MAIN HALL. Francis Fries was an industrialist who also designed buildings, such as the Main Hall for the Girls' School that was occupied in 1856. Situated right on Salem Square, next to Home Moravian Church, Main Hall was built in the Greek Revival style. This building was considered innovative at the time, with its two-story portico and fluted columns. Main Hall was used for study parlors and dormitories but currently houses offices and classrooms.

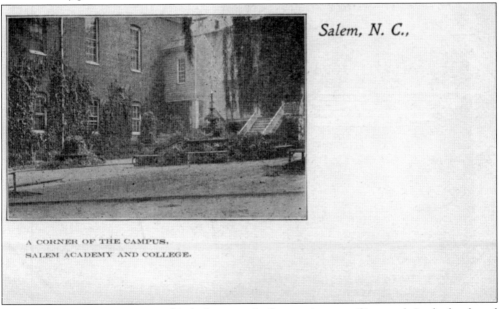

A CORNER OF THE CAMPUS. This is the second of two private mailing cards in the book and shows the courtyard behind Main Hall, with the chapel on the left. The small wooden attachment to the chapel was replaced with an enclosed brick structure covering the staircase. The tall and ornate cast-iron fountain near the stairs to the right bears the name of Wood and Perot of Philadelphia on its upturned base. (SV.)

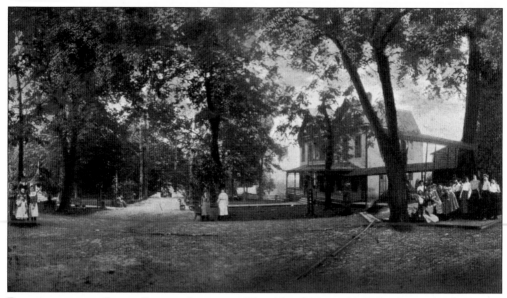

PLAYGROUNDS OF SALEM FEMALE ACADEMY. The title of this card is "Play Grounds of Winston Female Academy, Winston-Salem, N. C." The mention of Winston is confusing, because the location is clearly Salem Female Academy, and the building on the right is Society Hall, built in 1892. The playgrounds were areas that were suitable for walking among the trees or other plantings and for taking pleasure in the surroundings. (RS.)

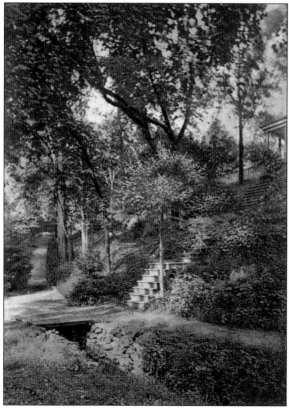

PLEASURE GROUNDS. After the Gemein Haus was removed and Main Hall was built, Principal Robert de Schweinitz designed an area at the back of the campus into a park. Part of the construction was made with stones from the Gemein Haus, and some of the dirt came from digging the basement of Main Hall. De Schweinitz made walks, nooks, and arbors in the park and built pavilions. The creek ran through the pleasure grounds, and generations of girls enjoyed its cooling waters.

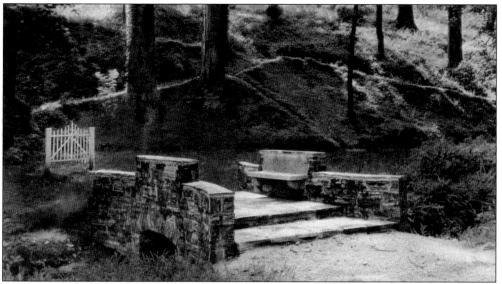

MEMORIAL BRIDGE AND SUMMER HOUSE. The classes of 1929 and 1930 are remembered with their gifts of the stone benches over the creek in the pleasure grounds. May Day was celebrated here for over 40 years with the crowing of a May Queen, the honoring of May Court attendants, and reveling in the enjoyment of spring. The May Queen and her court were escorted down the hill (above) and took their places on the stone steps. Entertainment followed, usually in the form of a pageant acted out by Salem students. Family members and friends found their seats on the grassy hillside overlooking the May Dell. This slope was fashioned into the amphitheater in 1966. May Day festivities ended in 1969 and are but a memory, similar to the Summer House (below) that once existed on the campus grounds. (Below, OSMG.)

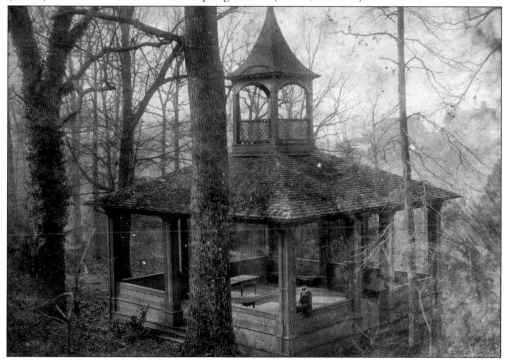

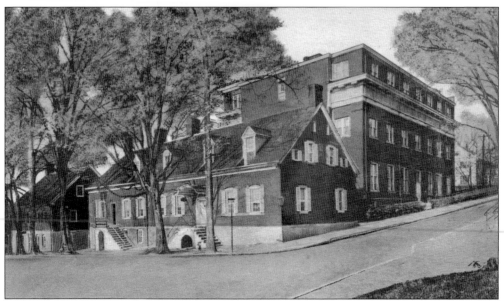

MEMORIAL HALL. When Memorial Hall (right) was in the planning stages, the original thought was to tear down the Inspectors' House (center), and Memorial Hall would be visible and compliment Main Hall and South Hall, both large buildings also located around Salem Square. Instead, Memorial Hall lived its life (1907–1966) behind and towering over the Inspectors' House. Memorial Hall was demolished in 1966, and the Salem Academy and College Fine Arts Center fulfills its function as a performance and meeting hall.

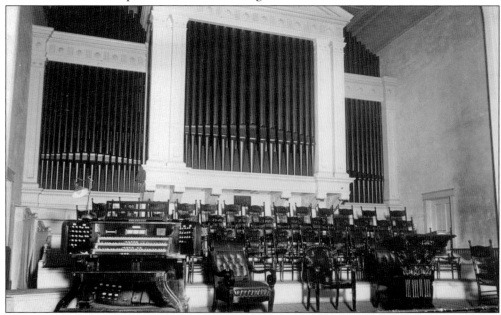

FOGLE MEMORIAL ORGAN. The 100th anniversary of the college was celebrated in grand style in 1907 with concerts and programs in connection with the commencement services, all of which took place in the new Memorial Hall. The star of the musical programs was the immense organ, costing $12,000 and given in memory of Christian H. Fogle by his family and friends. Fogle was a former mayor and town commissioner of Salem. (OSMG.)

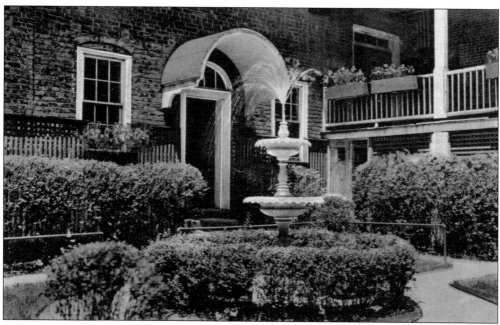

FOUNTAIN COURTYARD. The courtyard shown in both postcards is behind South Hall, although it looks a little different today. In 1966, South Hall was completely gutted, with only the original walls remaining. A section on the north side of the building was removed, thus changing the configuration of the porch (above) to the right. A bronze plaque on the fountain indicates that it was a gift to the school from Bishop Edward Rondthaler, president of the school from 1884 to 1888. There is also a plaque nearby that recognizes the courtyard beautification in 1975 as a memorial to Jane Lyle Veazie. To the far right (below) is the Annie Spencer Penn Alumnae House. Built in 1802 for a washhouse, pantry, and saddle room, the building was converted to the alumnae office in 1949 with accommodations for visiting alumnae.

SOUTH DOOR OF THE SISTERS' HOUSE. The Single Sisters did not intentionally wait 14 years to have their own house, but circumstances beyond their control delayed its construction. In 1783, plans were well underway for construction of the Single Sisters' House, and materials were already being ordered and gathered. Disaster struck in January 1784, when the Salem Tavern burned, and these materials were redirected for use in its rebuilding. Finally, in 1786, the new Single Sisters' House became home to 32 Single Sisters and Older Girls.

EAST SIDE OF THE SISTERS' HOUSE. By waiting until 1786 to build their house, the Single Sisters were able to build a larger and a more fortified structure. Because the tavern fire was on the minds of Salem residents, brick was used for the exterior and tile was used on the roof. Also, because the tile roof would be costly, it was decided to make the building larger than was originally planned in anticipation of future growth. The building was dedicated with songs, prayers, and a lovefeast.

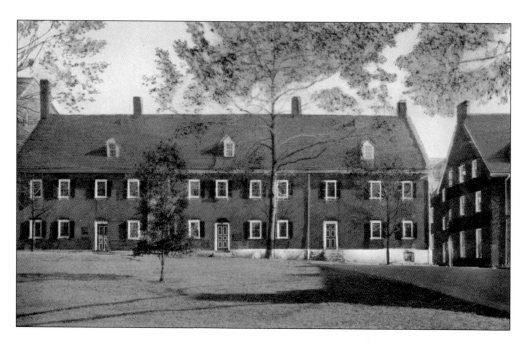

THE SINGLE SISTERS' HOUSE. Women in the Single Sisters choir lived and worked together. In their communal society, the money that was earned from their many industries paid for their living expenses. Some Sisters worked in the house (above) in various crafts, such as weaving and glove making; some were teachers; and others worked in the community. At one time, the Single Sisters took care of the laundry and the cooking for the Girls' School. In 1910, the house was given to Salem Academy and College, and it was used as a dormitory. In 2007, the building was completely restored. During the restoration, a board from the central staircase (below) was removed, revealing the original steps on which someone had written their initials and a date, 1883. The staircase was reconstructed to its original 1786 configuration. (Below, MA.)

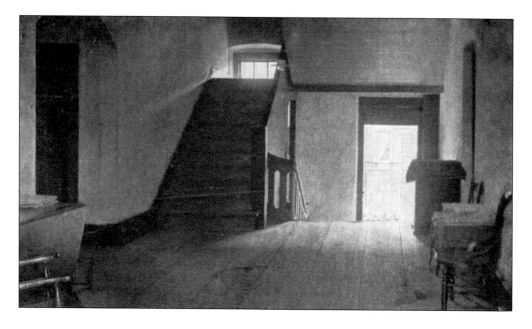

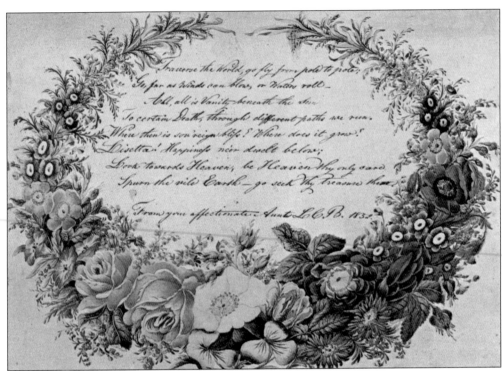

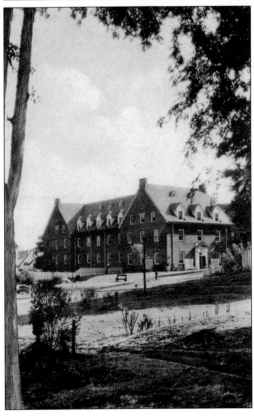

WATERCOLOR AND INK ON PAPER, 1832, BY BLICKENSDERFER. Louise Charlotte Blickensderfer was a teacher at the Salem Female Academy from 1814 to 1837. She was the daughter of Rev. Samuel Kramsch, who served as the first principal of Salem Female Academy from 1802 to 1806. Louise painted this full-page wreath of delicate flowers encircling a verse in 1832 for her two-year-old niece Lisetta or Lizette "Letty" Van Vleck. (WLB.)

ALICE CLEWELL DORMITORY. John Henry Clewell was the 11th president of Salem Academy and College, serving from 1888 to 1909. He was a native of Salem and taught for a year in the Boys' School before he left to further his education. Dr. Clewell returned to Salem to become assistant principal of Salem Female Academy at the request of the principal, Dr. Edward Rondthaler. In 1888, Dr. Rondthaler retired as principal and Dr. Clewell became principal. Alice Clewell Dormitory is named for Dr. Clewell's wife. (SACA.)

WEST ENTRANCE, CLEWELL DORMITORY.
Alice Clewell took an active part in
her husband's administration and was
recognized for her service and good taste
in social occasions. Clewell Dormitory was
built in 1922, and the expansive building
faces Church Street. In 1909, Dr. Clewell
left Salem to take a similar position in
Bethlehem, Pennsylvania. When Dr. Clewell
died in 1922, the participants in his funeral
were Drs. Edward and Howard Rondthaler,
the men who preceded and succeeded
Clewell as principals of Salem College. (MA.)

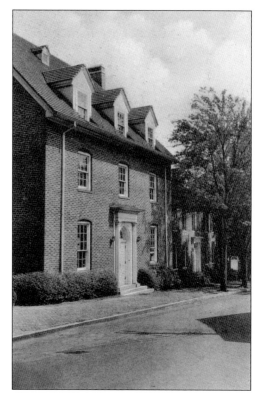

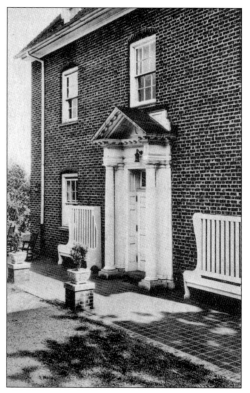

NORTH ENTRANCE, CLEWELL DORMITORY.
Dr. Clewell made his mark on the school in
many ways, such as in the erection of several
new buildings and in the expansion of the
scholastic program. He also wrote the book
History of Wachovia in North Carolina, published
in 1902, with historical information on
Salem and Salem College. An endowment
campaign was begun for the school in 1920,
and the first building constructed from the
money raised was the Clewell Dormitory.

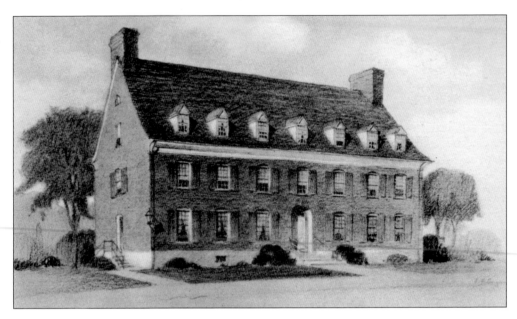

LOUISA WILSON BITTING DORMITORY. Louisa P. Wilson was the daughter of Dr. George and Henrietta Wilson of Bethania. She entered Salem Academy in 1851 and later married Joseph A. Bitting. One of their daughters, Kate Bitting Reynolds, gave the money to build the dormitory, seen above, in memory of her mother in 1930. Kate Reynolds was also an alumna of Salem Academy, and she was married to William Neal Reynolds. The postcard below shows Louisa Wilson Bitting Dormitory to the left with part of Clewell Dormitory to the right. Some reference sources say that the design of the dormitory is reminiscent of the 1771 Congregation House, or Gemein Haus, where the school first held classes for young girls. The area in front of the dormitories is planted in trees, shrubbery, and flowers.

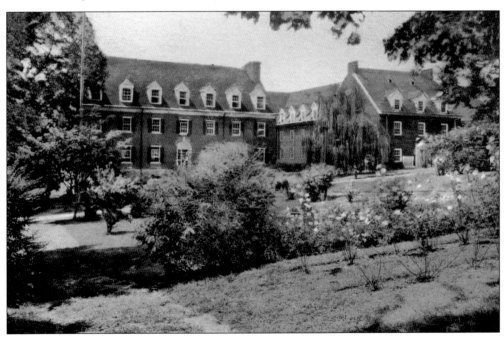

SOCIETY HALL. Occupied in 1892, the three-story wooden building was located in the rear of the chapel and replaced the woodsheds and the piles of wood at that site. Classrooms occupied the first floor, and the third floor was later used as a museum. On the second floor, the Euterpean Society (involved with music) occupied the east side, and the Hesperian Society (involved with debates) was located on the west side. The second floor was a lively place when society members were fully involved.

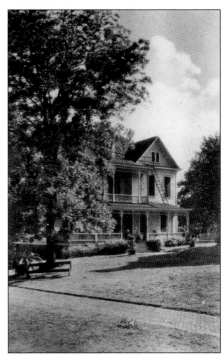

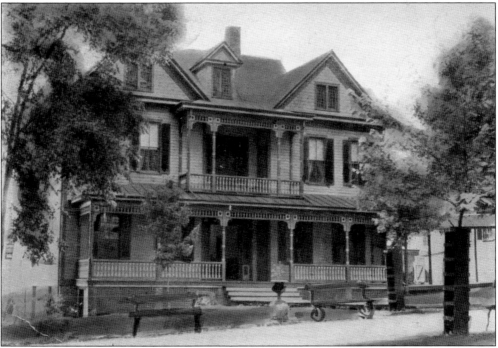

SOCIETY HALL, 1905. The sender of this postcard, dated 1905, remarks that he is "here on an orchestra trip," so it is fitting that the music society building postcard should be selected and mailed. At the dedication of the hall, the suggestion was made that the societies might hold some entertainment to help raise money to contribute to the cost of their new quarters now that they have a fixed home. (WLB.)

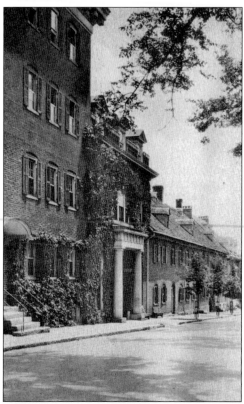

SOUTH HALL, WEST GATE ENTRANCE, AND SISTERS' HOUSE. Nestled between the imposing South Hall and the shorter Single Sisters' House, the West Gate Entrance (center) was originally an open gateway. As the first building constructed under the presidency of Dr. Howard Rondthaler, and designed by Willard Northup, West Gate Hall (1911) provided a driveway into the college grounds. The building contained offices, classrooms, and dormitories. West Gate Hall was demolished in 1966. (SV.)

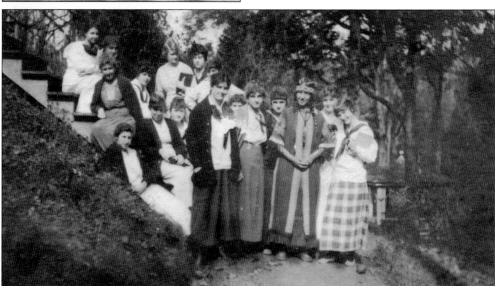

PRINCESS REDFEATHER CONCERT. Charles Wakefield Cadman was a renowned composer when he appeared in concert on November 11, 1915, in Memorial Hall. Cadman had a special interest in Native American music and produced a Native American grand opera in three acts titled *The Land of the Sky Blue Water*. He was accompanied by Princess Tsianina Redfeather, a young Native American mezzo-soprano singer, who wore a traditional Native American dress that she designed, sewed, and trimmed with beads. (WLB.)

THE INFIRMARY. Henry Theodore Bahnson (1845–1917) moved to Salem when he was four years old and studied in the Salem Boys' School before he attended college. Dr. Bahnson was a Civil War veteran and a prisoner of war twice during his term of service. After the war, he studied medicine and returned to Salem, where he practiced medicine and served as the attending physician for Salem College and Academy for 30 years. The Bahnson Memorial Infirmary opened in 1925. The building currently serves as a dormitory.

SALEM COLLEGE GYMNASIUM. The small, one-room wooden building, called the "Hut" and measuring 60 feet by 35 feet, was not large enough or sufficiently outfitted to handle the athletic needs of the 300 students enrolled in 1931. This was the plea from students voicing their desire for a new gymnasium. Their arguments were heard, and a new and modern gymnasium (shown above) was built in 1936. (WLB.)

PRESIDENT'S RESIDENCE (ANNEX HALL). The building, occupied in 1888, has been called by several names; originally, it was called Annex Hall. The wooden structure housed the 9th and 10th room companies. The younger girls moved to another residence, and the seniors claimed the building in 1912 as their own, referring to their abode as Senior Annex. Then, during Dr. Howard Rondthaler's term as president, the building was known as the President's House, beginning in 1923. The house was restored and is currently called the Rondthaler-Gramley House, used for social events, meetings, and guests. The steps in front of the house are inscribed, "E. A. Lehman Memorial, By Her Girls, 1864–1914." This memorial is in honor of Emma A. Lehman (1841–1922). Born in Bethania and a graduate of Salem Female Academy, Lehman began her 51-year teaching career at Salem in 1864.

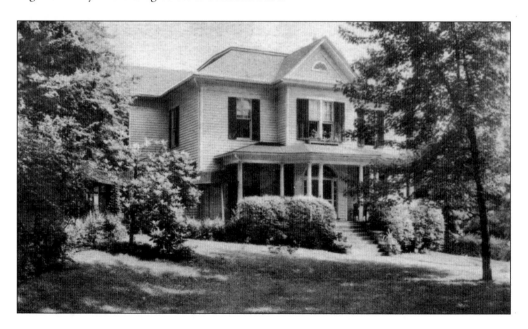

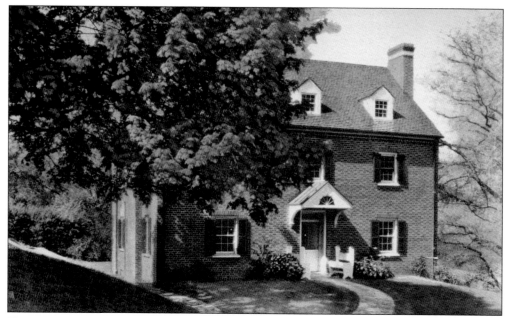

HOME ECONOMICS BUILDING. Katherine Jane Hanes honored her mother, Lizora Fortune Hanes, by giving the Home Economics Building to the college in 1930. Mary Lizora Fortune, a native of Texas, married Pleasant Henderson Hanes in 1873. Hanes was the founder of P. H. Hanes Knitting Mills, and he and his wife were the parents of seven children. The Hanes building offered seniors an opportunity to apply what they had learned in class and laboratory work.

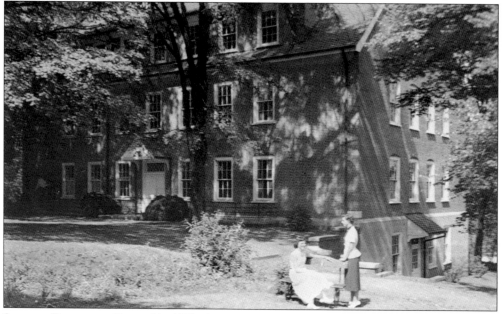

SCIENCE BUILDING. Opened in 1951, the new science building contained all the most modern equipment and furnishings available for the study of the sciences. Features of the new building included well-stocked laboratories, tiered lecture rooms, a spacious home economics department, microscopes, and ventilation systems for chemicals. The building was expanded in 1960 and 1993 and was named in honor of Dr. Howard Rondthaler, Salem's president from 1909 to 1949.

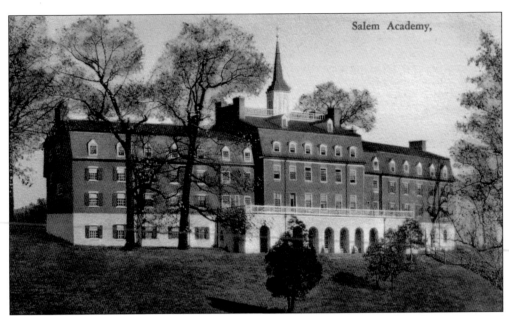

SALEM ACADEMY AND RECEPTION ROOM. Salem Academy and Salem College separated academically in 1912, and as both schools continued to grow, they needed more room for classes, dorms, and other activities. The answer to the crowding dilemma came in 1930 as a gift—actually as three gifts, as three families united to honor their mothers by donating wings that would be joined to form a new academy building (above). The honored women were sisters, all daughters of Francis and Lizetta Vogler Fries, and all were graduates of Salem Academy. The center building was given in honor of Mary Fries Patterson (1844–1927), the west wing was given in honor of Caroline Fries Shaffner (1839–1922), and the east wing was given in honor of Emma Fries Bahnson (1852–1945). Emma Bahnson's portrait (below) can be seen on the wall of the east reception room. (Both, WLB.)

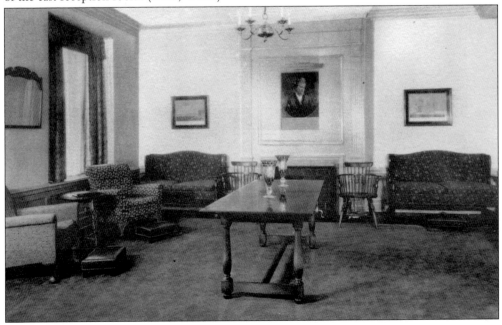

SALEM ACADEMY CLOISTERS. The cloisters are the arched openings on the side of the building facing the college, in the center. Over the cloisters is a sun portico, which offers spectacular views of Salem College and the surrounding area. Presentation services for the new building were held in the Memorial Chapel, with contractor H. A. Pfohl turning over the keys to the new facility. Portraits of all three women and those of their parents are hung in the hallway and reception rooms of the academy building. (SMM.)

FRONT VIEW OF SALEM ACADEMY. The Fries sisters, Caroline, Mary, and Emma, were civic-minded women who participated in many worthwhile endeavors during their lifetimes. Working together, some of their projects concerned the establishment of the Twin City Hospital Association and the first hospital in town and the Salem Home of the Moravian Church for homeless women and children. They were also active in their church and were mothers to a total of 19 children. (WLB.)

SALEM ACADEMY, EAST FRONTAGE. At the dedication service in August 1930, the new Memorial Bell rang for the first time. A musical program was presented, and Frank Patterson, son of Mary Patterson and editor of the *Baltimore Sun* newspaper, spoke on behalf of the donors. An architectural feature of the new building was the Zinzendorf Memorial Tower, shown atop the center section, which was a reproduction to scale of a tower designed by Count Zinzendorf and erected upon an ancient school building in Pennsylvania. (SV.)

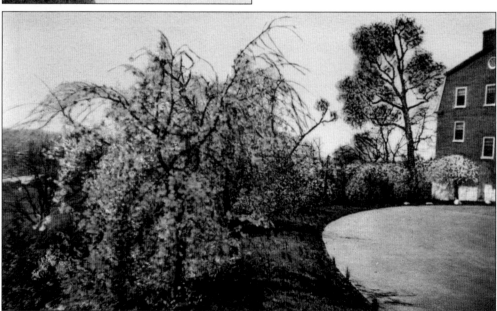

SALEM ACADEMY DRIVEWAY. The view to the right shows the end of the original academy building until the Mary A. Weaver Wing was constructed in 1956 in honor of Mary Weaver, principal of the academy from 1931 to 1959. At the opposite end of the academy building, the Mary McCoy Hodges Hall and the Lucy Reynolds Critz Classroom Building were erected in 1971. (SV.)

SALEM ACADEMY DINING HALL. A corner in the new dining hall in the academy building was designed to be a reproduction of an earlier dining hall in the academy's history. When South Hall was built in 1805, the meals were cooked in the Single Sisters' House and brought next door to the cellar where the dining hall was located. Boards were laid across sawbucks to make tables, and these were covered with coarse tow linen. When the weather turned cooler, the tables were set up on the first floor.

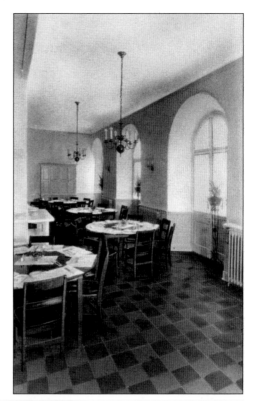

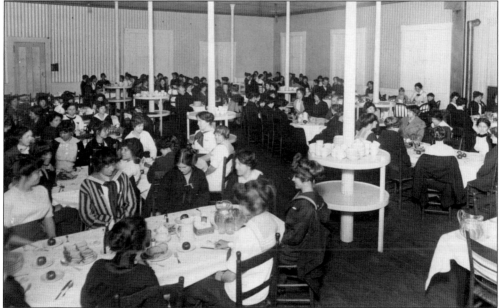

DINING HALL. Students have gathered around the dining tables outfitted with linens and china to discuss the events of the day. This scene changed in 1941 with the construction of the Hattie M. Strong Refectory, which was equipped with all new furnishings and decorations. Students were glad to know that Gus Bruner, the college baker, would have a bakery with a new mixer and ample ovens in the new facility. (SACA.)

Greetings from Salem. Thanks for the postal, just told Louise yesterday, how much I wished I had a picture of our line up. Am very much afraid I won't get to go to see U.C. beat Va Thanksgiving, but chances are very slim at present. I gets sick when I think about our not going. I hope I will see you soon if not at Richmond.

SALEM COLLEGE PENNANT, 1908. "Polly" is the sender of this postcard sporting the Salem College pennant, which was mailed in November 1908 to a University of North Carolina student. She thanks her correspondent for the "postal" of the UNC lineup and expresses her hope that UNC will beat Virginia when they play at Thanksgiving. Many students enjoyed collecting postcards of different places, which they fitted into scrapbooks designed just for postcards. (WLB.)

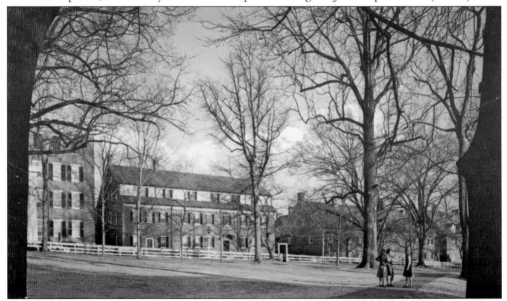

SALEM SQUARE AND SOUTH HALL. The fence around Salem Square and the restored South Hall (center) help to date this postcard to after 1966. The buildings on either side of South Hall were removed, and the look was changed to its original 1805 facade, giving a realistic view of this area at the middle of the 19th century. Salem College is at home in its original and historic surroundings as a modern educational institution. (JB.)

Five

WINSTON–SALEM AND ENVIRONS

WEST FOURTH STREET, LOOKING WEST. The area around courthouse square was always a popular business location, as shown in this view of West Fourth Street looking west. The S. H. Kress Company building to the far right was occupied in the late 1970s by Hinkle's Book Store. The entire block to the right was demolished to make room for One West Fourth, a multiuse office building with Wachovia Corporation as the primary tenant.

West Fourth Street, Looking East. Identifying and dating downtown skyline postcards relies on determining which photographs were made before the construction of the Wachovia Building (completed in 1966) and which were made after its construction. The above aerial falls into the former category, which makes it before 1963, when construction began on the building that occupies the 300 block of Main Street. The Reynolds Building stands nearly at the center of the postcard, with a cluster of R. J. Reynolds Tobacco Company factories at center left. The postcard below is a street-level view of West Fourth Street taken from Spruce Street looking east and showing the traffic going both ways, as is the current traffic pattern for the street.

MAIN STREET, LOOKING NORTH. Main Street is a connector street between Salem and Winston. The line dividing the towns was at First Street, with all east-west streets from Main numbered consecutively. This photograph, taken looking north, shows the end of the 100 block of North Main Street, with Second Street crossing Main. The Reynolds Building at 401 North Main Street can be seen in the center. The "Hotel" sign on a lower building refers to the Zinzendorf Hotel on the 200 block of Main Street. (CDS.)

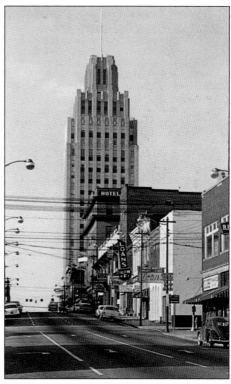

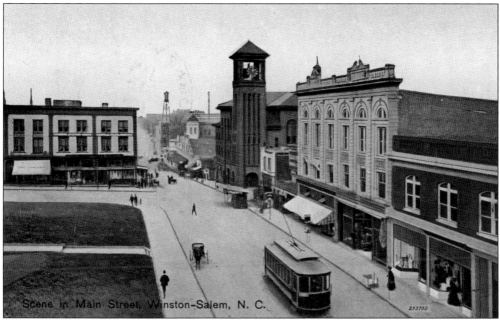

MAIN STREET AT FOURTH STREET. The streetcar is traveling past the 300 block of Main Street, across from the courthouse, in this 1912 postcard. The tall building with the clock tower is town hall, and to its north is Brown's Tobacco Warehouse. The building to the right with the ornate facade was divided into two parts, with the left part occupied by S. H. Kress Company in 1906, the year the building was constructed.

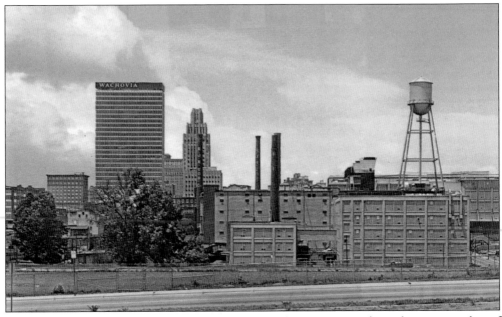

SKYLINE FROM HIGHWAY 52. The north-south Highway 52 runs along the eastern edge of Winston-Salem. The buildings at the forefront, seen from Highway 52 and near the center of the photograph, are part of the R. J. Reynolds Tobacco Company Number 64 complex of cigarette manufacturing facilities. Constructed in the 1920s, these buildings are obscured from this location today by a processing plant that was built by Reynolds in the 1980s.

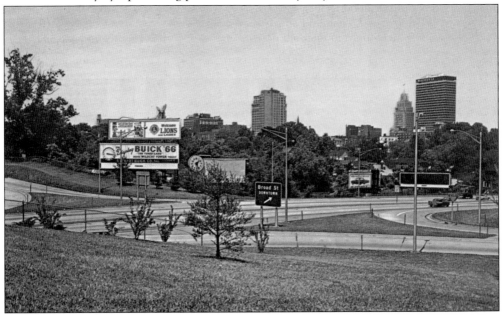

INTERSTATE 40 AT BROAD STREET. Before the Interstate 40 bypass was constructed, the volume of traffic passing through Winston-Salem on Interstate 40 was always heavy. Billboards frequently dotted the stretches of highway through downtown, in this case advertising the local business of Stewart Buick and welcoming the Lions Clubs to town. The interchange shown here is at Broad Street, with the downtown skyline as seen in 1966.

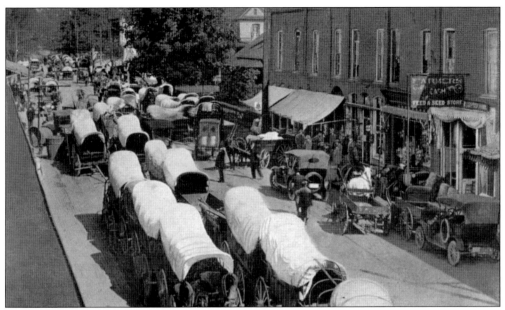

TRADE STREET. When Piedmont Tobacco Warehouse moved from the corner of Fourth and Trade Streets to a new location in the 500 block of North Trade Street (left), the wagons, trucks, and cars associated with the tobacco market also moved farther north. The Farmer's Feed and Seed Store (right) had an excellent business location, particularly during the tobacco market, when farmers came to sell their tobacco and purchase goods with their profits to take home.

TOBACCO AUCTION. There was a time in early tobacco warehouse history when a bell would be rung whenever a farmer arrived with a load of tobacco. The tobacco buyers would hurry from the nearby factories, gather around the tobacco, and bid on it until it was "knocked off." Later tobacco auctions were more sophisticated and organized, with millions of pounds of tobacco crossing the auction floors.

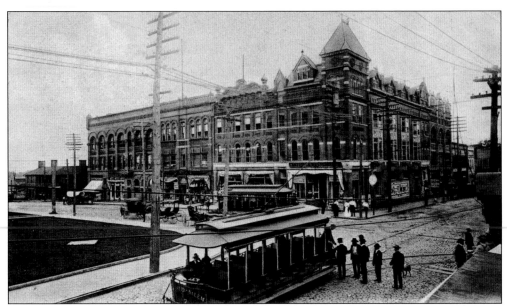

FOURTH AND LIBERTY STREETS. It appears to be a busy day at the intersection of Fourth and Liberty Streets in front of the Phoenix Hotel, shown in the center in this card postmarked in 1906. A conductor is helping a passenger alight from the open-air streetcar at the forefront of the photograph, while another streetcar is coming behind and rounding the corner. Horses and buggies, and even a covered wagon, are traveling on Liberty Street.

AERIAL OF THIRD STREET. Early city planners had ambitious hopes for the town of Winston, but even their most grandiose plans did not see the need for Third Street to go farther west than Cherry Street, so West Third Street, at the center of the postcard, ends at the First Presbyterian Church. This aerial view shows West Third Street, looking west from Liberty Street. The First National Bank Building is on the corner to the right.

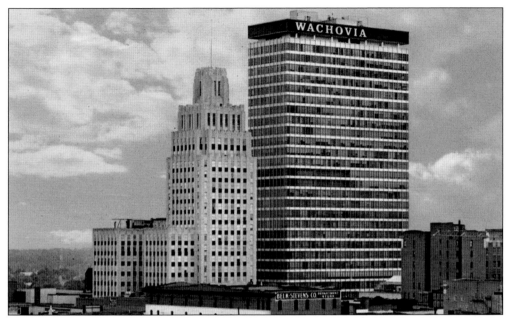

REYNOLDS AND WACHOVIA BUILDINGS. Winston-Salem welcomed the news that Wachovia Bank intended to build a multistory office building on Main Street across Fourth Street from the Reynolds Building. When the building was dedicated in 1966, the public was invited to tour the new quarters and to examine the view of the city from a higher perch than was possible before. This tall twosome represented the largest employers in town for many years.

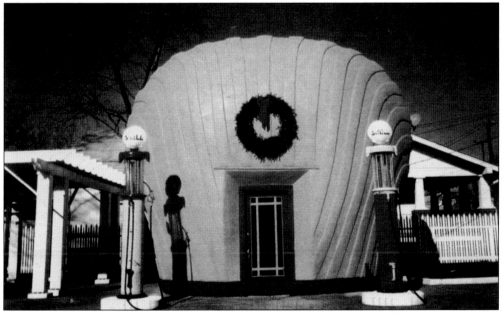

QUALITY OIL "SHELL" SERVICE STATION. The first of eight shell-shaped, yellow-orange Quality Oil service stations opened in 1930 on Burke Street and was constructed of concrete, green wood, and wire. Seven of these stations were either modernized or replaced, leaving the station at 1111 East Sprague Street near Peachtree Street as the lone reminder of these unique buildings. Preservation North Carolina restored the station and leases it for a satellite office.

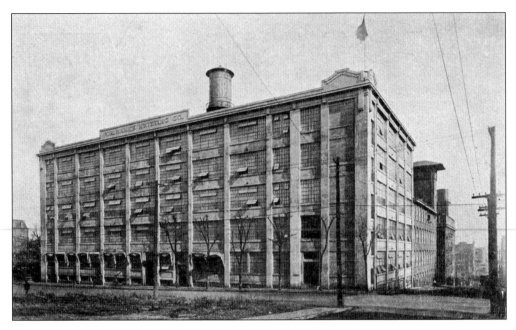

P. H. Hanes Knitting Company. Printed across the top of the reinforced steel and concrete building above is "P. H. Hanes Knitting Co." Erected in 1915 on the corner of Main and Sixth Streets, the new building featured ample space for machines and workers, high ceilings, and both natural and artificial light. Good lighting was a necessity for the workers who operated the machines that made Hanes merchandise at this location. One of the sewing and finishing rooms for P. H. Hanes Knitting Company is shown below. Hanes was one of the first companies in the South to manufacture knitted underwear. Union suits were made by the company in 1913, and business increased to the point that a new downtown factory was built to the north of this factory in 1920. (Both, JWC.)

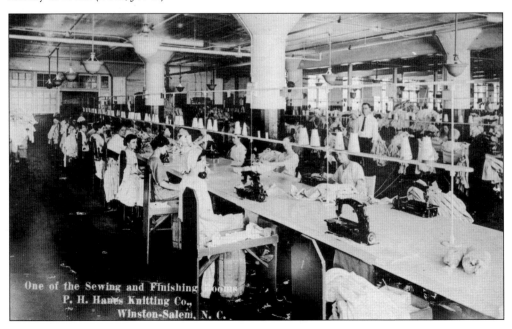

One of the Sewing and Finishing Rooms
P. H. Hanes Knitting Co.,
Winston-Salem, N. C.

HOUSE OF PLANTS. Mary and Barry Boneno started their flower and plant business in 1976 at 507 Harvey Street. This postcard, with partners Pat Dolge (left) and Mary Boneno (right), was mailed in 1983 to advertise their annual Christmas open house. The business has expanded to include a wide range of flowers, plants, and gifts and is located in the former Hanes Baptist Church parsonage in the Hanes Mill Village. (MBRB.)

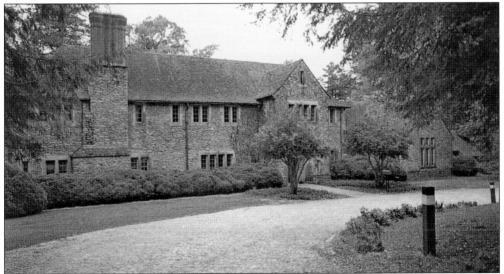

SECCA. The Southeastern Center for Contemporary Art (SECCA) opened in 1956 as the Winston-Salem Gallery of Fine Arts. In 1977, the center moved into the 1929-era former home of James Gordon Hanes on Marguerite Drive. The house, photographed by Charlie Buchanan, was renovated and expanded. In 2007, SECCA became an arm of the state-supported North Carolina Museum of Art. Closed in 2009 for extensive renovations, SECCA reopened in July 2010. (SMM.)

WACHOVIA BANK. The beginnings of Wachovia Bank can be traced to the establishment of the Cape Fear Bank in Salem in 1848. The bank closed at the outbreak of the Civil War and reopened following the war as the First National Bank of Salem. The bank directors decided to move the bank to Winston. Since there was already a First National Bank in Winston, a new name was chosen and a new charter was issued in 1879 for Wachovia National Bank of Winston. The Wachovia Loan and Trust Company was formed in 1893, shown on Main Street to the left of center above, next to the James Alexander Gray house to the right. The two banks consolidated in 1911 and built a new bank at the corner of Main and Third Streets. Part of the bank's lobby is shown below. (Above, JWC.)

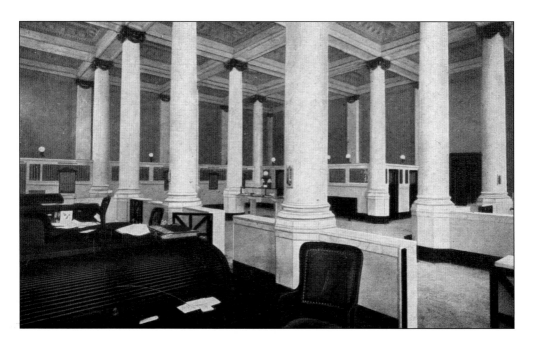

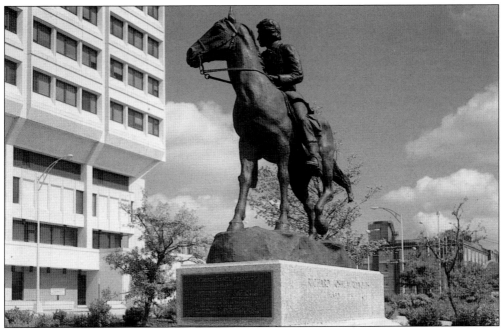

R. J. Reynolds Tobacco Company. Richard Joshua Reynolds rode into the town of Winston in 1874 from his home in Virginia. Reynolds (age 24) and the town of Winston were nearly the same age. Earline Heath King, a sculptress and a native of Winston-Salem, captured the young Reynolds atop his horse in a 12-foot bronze statue (above) that stands on the corner of Main and Second Streets. Even at his young age, Reynolds already had experience in the growth and marketing of tobacco, plus business training, so he immediately bought a lot and built his red two-story tobacco factory next to the railroad tracks on Depot Street (now Patterson Avenue). Reynolds lived on the second floor of the factory. The painting by W. Stuart Archibald (below) shows the factory in which the company began operations in 1875.

THE FEDERAL BUILDING AND THE HALL OF JUSTICE. Located across North Main Street from each other, the Federal Building (left, 1976) and the Hall of Justice (right, 1974) centralize the national and local courts and offices. At the dedication, the Federal Building was described as a "monument to our democracy." The Hall of Justice was dedicated on the 187th anniversary of Andrew Jackson's admittance to the bar in what is now Forsyth County.

TERMINAL BUILDING, SMITH REYNOLDS AIRPORT. Miller Municipal Airport opened in 1927 with a visit from Charles Lindbergh. Fifteen years later, a terminal building was constructed and financed by Richard J. Reynolds Jr., Nancy Reynolds Bagley, and Mary Reynolds Babcock and named for the financers' late brother, Zachary Smith Reynolds. To celebrate the airport's 35th anniversary in 1962, Russell Church Studios made and donated a large multicolored window made of mosaic glass that featured local scenes.

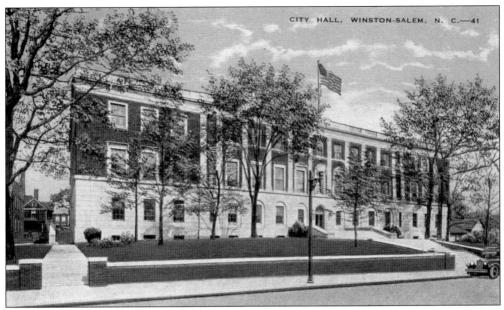

WINSTON-SALEM CITY HALL. The city of Winston-Salem bought the lot on the corner of Main and First Streets in 1920 and began clearing underbrush for construction of the new city hall, which opened in 1926. The exterior architectural design work was done by Wyatt Hibbs of Northup and O'Brien. In 1928, C. S. Leo was awarded the contract to construct a stone wall around the grounds in front of the new city hall.

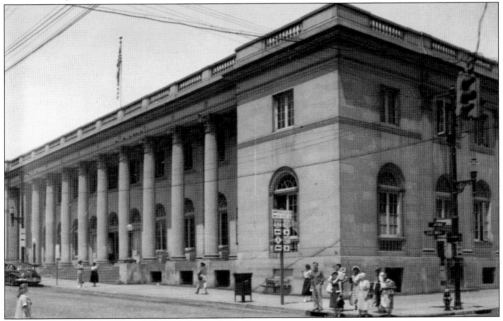

U.S. POST OFFICE. Salem established a post office in 1792, while Winston's post office was established in 1851. The post offices of the two cities were consolidated in 1899 under the name of Winston-Salem. The building here on West Fifth Street was constructed in 1915 and expanded in 1937. Federal court facilities were located on the second floor. A new post office was built on Patterson Avenue, and the building is known today as the Millennium Center.

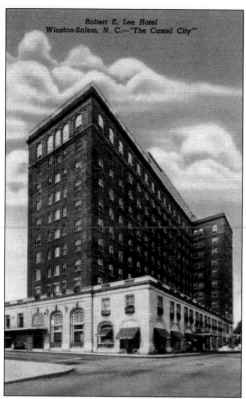

Robert E. Lee Hotel
Winston-Salem, N. C.—"The Camel City"

THE ROBERT E. LEE HOTEL, 1956. From 1921 to 1972, the Robert E. Lee Hotel provided lodging, entertainment, and good food to travelers and city residents. Located on West Fifth Street, between Cherry and Marshall Streets, the 11-story hotel made an impression on the writer of this postcard. The message states, "This is where Mother, Daddy, Evelyn and I spent Easter 1956, March 30–April 1, 1956 for Moravian Services." The postcard was not mailed but likely was kept as a souvenir of the trip.

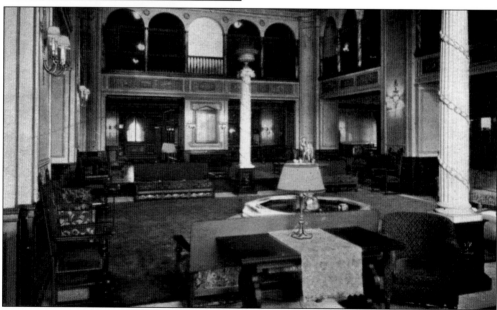

ROBERT E. LEE HOTEL, INTERIOR VIEW. If the directors of the Winston-Salem Hotel Company had their way in 1920, "The Huntley" would have been the name of the new hotel, after B. F. Huntley, president of the company. Although honored with this consideration, Huntley suggested that another name be chosen. The directors chose Robert Edward Lee as the man to honor and decorated the hotel lobby in historical tribute to the famed Confederate general.

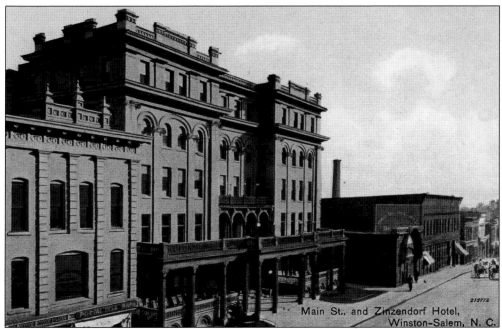

Main St., and Zinzendorf Hotel,
Winston-Salem, N. C.

THE ZINZENDORF HOTEL, 1912. When the first Zinzendorf Hotel opened and burned in 1892, the city leaders and the hotel's financial backers lost their dream of promoting Winston-Salem as a resort community. However, the city still needed a first-rate hotel, and a new Zinzendorf Hotel was built in 1906 on North Main Street and named for Count Nicholas Zinzendorf, the patron who sheltered and supported the Moravians in their quest for religious freedom. (JWC.)

CAROLINA HOTEL AND THEATRE. The $1-million movie theater, which also included a hotel, opened on January 14, 1929. *On Trial* was the talkie shown at the theater's dedication, and it was the first of many movies shown at the popular theater on West Fourth Street. Movies, stage shows, kiddie shows, teenage dances accompanied by local combos, and church services occupied the theater's lineup until it closed in 1975. After extensive refurbishing and restoration, the Stevens Center opened here in April 1983.

HOLIDAY INN ON SOUTH CHERRY STREET. Before January 1960, the only motel in town was the locally owned Kembly Inn. Howard Johnson opened the first chain motel in 1960, and it contained 82 units. Holiday Inn tried for four years to penetrate the local market and finally succeeded when their 104-unit motel opened in 1962 at Cherry and Trade Streets and Brookstown Avenue, complete with a coffee shop, restaurant, and banquet hall.

PARKWAY CHALET MOTOR LODGE. Advertised as "Your host for greater quality," Parkway Chalet Motor Lodge opened in 1962 at 600 Peters Creek Parkway. The 90-unit motel sat on the hill near Peters Creek and offered services such as televisions, executive suites, convention and meeting rooms, direct-dial telephones, a swimming pool, a putting green, and a taproom. Many local residents remember dining and dancing in the motel's Alpine Room Supper Club.

GREYSTONE DOWNTOWN MOTEL. The renovated and refurnished Greystone Motel was formally opened in April 1962. Located at 650 West Fourth Street, Greystone contained 85 rooms and suites, each with a tile bath and wall-to-wall carpeting. Other features included telephones, air-conditioning, and the very useful perk of free downtown parking. Following the demolition of the Greystone, a parking deck was constructed on this property. (WLB.)

BROOKSTOWN INN. If the walls of the Brookstown Inn could talk, they would tell of its early days as a cotton and flour mill. They would tell stories of the mill workers who rejoiced when it became the first Southern factory to be lit by electricity. Listed on the National Register of Historic Places and located at 200 Brookstown Avenue, the inn offers modern conveniences in a historic setting near the Winston-Salem Visitor Center and Old Salem. (WLB.)

AERIAL VIEW OF THE FAIRGROUNDS. War Memorial Coliseum opened in 1955 on Cherry-Marshall Street as a living memorial to all who served in World War II. During its lifetime, the coliseum was the site for basketball games, rodeos, citywide gatherings, and the Dixie Classic Fair. The fairgrounds can be seen surrounding the coliseum, with the permanent buildings and the grandstand behind the coliseum. Goodwill Industries is on the far right.

FORSYTH MEMORIAL HOSPITAL. Construction and hospitals seem to go together, and Forsyth Memorial is no exception. Located on Silas Creek Parkway, the hospital complex has filled in the vacant spaces beside the original building and constructed additional service facilities. The area surrounding the hospital has also proven to be attractive to other medical-related offices and businesses, which occupy the area behind the hospital covered in trees.

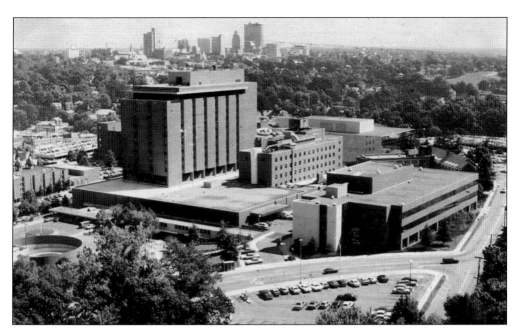

NORTH CAROLINA BAPTIST HOSPITAL. The Reynolds Patient Tower, shown to the center left above, opened in 1973 on the 50th anniversary of the hospital. Standing 16 stories tall, the Reynolds Tower was the most dramatic addition since the hospital opened in 1923. Designers chose colorful furnishings for the new facility to accent its open and light-filled rooms and lobbies. A favorite public area was the Penthouse Restaurant on the 12th floor, which was surrounded with windows that afforded panoramic views of the city. Building the Reynolds Tower was the second phase of the hospital's multi-million-dollar expansion that began in 1963. More changes would soon be coming, such as the opening of a new emergency room in 1974. The photograph below shows a section of the intensive-care unit of the hospital.

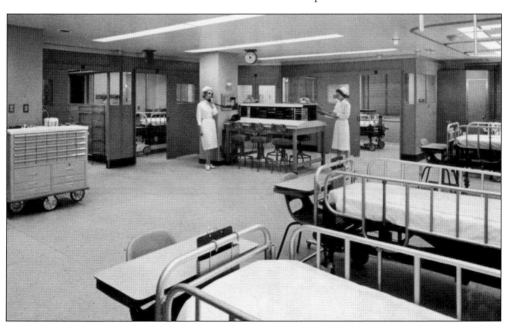

REYNOLDA VILLAGE
Shops & Restaurants

Experience

a unique shopping adventure

WINSTON-SALEM • NORTH CAROLINA

REYNOLDA VILLAGE. Soon after Katharine Smith married Richard Joshua Reynolds in 1905, they began to plan for the building of their country estate. A master plan was drawn for the estate by Buckenham and Miller, and some of the farm buildings were constructed before the house, designed by Charles Barton Keen, was built. Katharine's vision was a working and experimental farm situated in a village-type setting, similar to an English country estate. In addition to the house, or bungalow, the estate buildings included barns, silos, stables, a greenhouse, a dairy, a lake and boathouse, a blacksmith's shop, a church, and cottages for the farm managers and workers. Unfortunately neither Katharine nor R. J. lived to enjoy the fulfillment of their dream for the estate. Today visitors to Reynolda Village can experience and appreciate their vision and witness the commitment of many people who worked to save this unique place that offers shopping, dining, offices, and services in a timeless setting.

REYNOLDA HOUSE. R. J. and Katharine Reynolds entertained on the grounds of their country estate before they actually moved into their new home. In July 1916, they entertained over 400 guests, including the officers and traveling salesmen of the R. J. Reynolds Tobacco Company, with a grounds tour, dinner, and musical program. The guests were entertained at the boathouse (above) with a concert performed by Crouse's Band. Reynolda House Museum of American Art (below) reopened in 2005 after renovation work to the historic house and new construction of the Mary and Charles Babcock Wing. The house was renovated, with more rooms being opened for viewing and outfitted with original furnishings and with works of art featured throughout. The new wing contains exhibit space, a large auditorium, classrooms, an orientation gallery, and a gift shop.

WAKE FOREST UNIVERSITY AND GROVES STADIUM. In 2006, Wake Forest celebrated the 50th anniversary of its move to Winston-Salem from Wake Forest, North Carolina, where the school was founded in 1834. While college officials were busy with the cornerstone-laying ceremonies in 1953, two law students were busy planting a tiny magnolia tree that they brought from the old campus to be the "first" magnolia on the new campus. The fate of that first magnolia tree is unknown, but the school has definitely taken root in Winston-Salem. The campus buildings shown above are the Thurman D. Kitchin Dormitory and Reynolda Hall. Just as there was a Groves Stadium on the old campus, a new Groves Stadium (below) was opened in 1968 across from the coliseum. Deacon Tower replaced the press box in 2008, and Groves Stadium was renamed BB&T Field.

Winston-Salem State University. Slater Industrial Academy opened in 1892 and was started by Dr. Simon G. Atkins. Its first permanent building was constructed in 1896 with bricks that were made by the students in the school's brickyard. After several name changes, the school became Winston–Salem State University in 1969. The buildings shown on the postcard are the O'Kelly Library, Blaine Hall, and the Kenneth R. Williams Auditorium. (WLB.)

North Carolina School of the Arts. South Junior High School, built in 1930, became James A. Gray High School. In April 1964, the school board voted to offer the Gray High School building for use as the state school for the performing arts. Later that month, a telephone campaign raised $850,000 from individual donors to win the school for Winston-Salem. The former Gray High School building can be seen in the background in the center.

SAWTOOTH SCHOOL FOR VISUAL ART. Using the word "Sawtooth" for the name of a school might seem a bit unusual, but considering the sawtooth-like roof that allowed north light to enter the hosiery mill below, the name is appropriate. Under the sponsorship of the local arts council, the Sawtooth Building on Marshall Street has undergone renovation and expansion to provide a modern arts complex for "The City of the Arts."

GALLERY OF THE ARTS. Jim and Cathy Tedder created and developed the idea of the Community Arts Café (CAC) as a "media outlet dedicated exclusively to the coverage and support of the local arts." The CAC provides a platform for artists, musicians, performers, and arts organizations to gain local exposure. The Gallery of the Arts at 411 West Fourth Street is an exhibiting and retail gallery and outlet for the overall CAC Company.

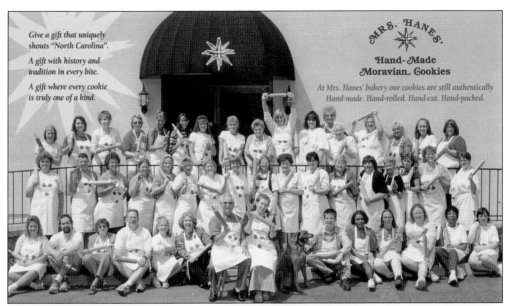

Give a gift that uniquely shouts "North Carolina".

A gift with history and tradition in every bite.

A gift where every cookie is truly one of a kind.

MRS. HANES'

Hand-Made Moravian Cookies

At Mrs. Hanes' bakery our cookies are still authentically Hand-made. Hand-rolled. Hand-cut. Hand-packed.

MRS. HANES' MORAVIAN COOKIES. Evva Foltz Hanes is a seventh-generation Moravian baker who continues the family tradition of hand-making, hand-rolling, hand-cutting, and hand-packing the cookies that her company makes and sells. Evva and her husband, Travis, are shown front and center with the other "Rockin' Rollers" (including the Hanes children and grandchildren) who create the delicious aromas that greet visitors at their company on Friedberg Church Road in Clemmons. (MHMC.)

SALEM COTTON COMPANY RESTAURANT. The restaurant opened in 1981 in a restored 1837 cotton mill, the Brookstown Mill, which is listed on the National Register of Historic Places. The Winston-Salem visitor center, called Visit Winston-Salem, is currently located in this part of the former mill. In 2010, the Cotton Mill Restaurant resides in the Brookstown Mill complex and features Southern cuisine in a historic setting. The postcard was made from a photograph by E. Alan McGee. (SV.)

Tar-Heel Postcard Club Celebrates

National Postcard Week May 7-13, 2006

TAR-HEEL POSTCARD CLUB, 2006. Postcard collectors are called deltiologists, and every year they celebrate National Postcard Week during the first full week in May. Individuals and postcard clubs design and exchange postcards to promote their hobby. The Tar-Heel Postcard Club began in 1978, and the postcard shown here is their 2006 commemorative card featuring Winston-Salem. Clockwise from the upper left, the images are the Reynolds Building, Robert E. Lee Hotel, the Coffee Pot, and the Confederate Statue. (WLB.)

NATIONAL BLACK THEATRE FESTIVAL. As the caption on the postcard reads, "Every other year, the North Carolina Black Repertory Company transforms the city into a showcase of African American talent at the National Black Theatre Festival. Thousands of participants join the country's most talented and highly acclaimed artists and performers as they celebrate quality theatre during this weeklong event." The festival was founded by Larry Leon Hamlin in 1989.

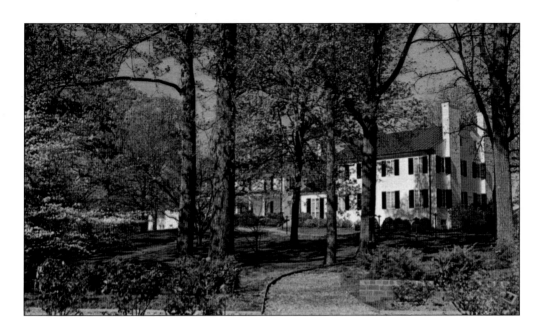

TANGLEWOOD PARK MANOR HOUSE AND ROSE GARDEN. Visitors to Tanglewood Park have many options for lodging, dining, and entertainment. The manor house, seen above, served as the home for William Neal and Kate Bitting Reynolds on the grounds of Tanglewood Park. When the Reynoldses lived there, it was an estate, and William Reynolds was particularly fond of raising and racing his harness horses. The manor house is a bed-and-breakfast inn that has been refurbished and offers Southern hospitality in a historic setting with activities nearby such as golf, swimming, picnicking, and horseback riding. The rose garden beside the manor house is shown below. The Tanglewood Steeplechase, a social and equestrian event, was revived in 2010 on the park grounds. The campgrounds have also been refitted, and they reopened in 2010.

"HOIST YOUR ANCHOR." This postcard was mailed to Montana and postmarked June 1913. The writer of the card was probably a visitor in town, because he mentions coming home in a few weeks. If that is the case, he might not have realized that it was barely a month since Winston and Salem officially joined to become Winston-Salem. The novelty postcard, with its nautical theme, was advertising the Twin City.

FOUR VIEWS OF SALEM. Pauline Bahnson Gray (1891–1955) loved Salem and loved to paint. She combined these two passions when she created her colorful and realistic paintings of Salem. She based her paintings on her memories of growing up and living in Salem and on earlier paintings by various artists. Gray's paintings were instrumental in providing visual documentation during restoration work in Old Salem. Four of her paintings, which show different views of Salem, are captured on this postcard. (C. Harrison Conroy Company.)

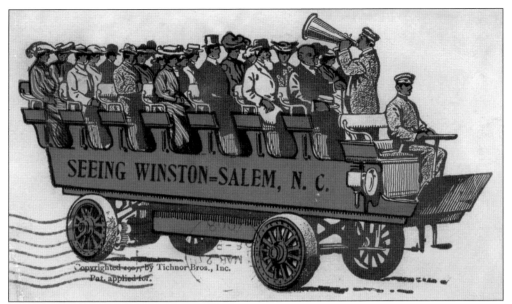

SEEING WINSTON-SALEM. The sightseeing bus is filled with visitors to the city in this novelty postcard dated 1908 that was sent to Nebraska. Unfortunately there are no other clues about the writer or the recipient of the postcard, because it is an undivided-back card, and there is no message on either side. The ladies and gentlemen on the bus are dressed in the latest fashions to see the sights in town. (WLB.)

MEET THE AUTHOR. Molly Grogan Rawls is a native of Winston-Salem and a postcard collector. She is standing in Old Salem near the Horton Center, with South Main Street behind her. To her right is a map of Old Salem Museums and Gardens detailing the houses and exhibit buildings that comprise the living history museum. Since its founding in 1772, Salem Academy and College has been located in the town of Salem. (Photograph by Jeffrey Rawls.)

Old Salem and Salem College Time line

1753, November 17	First Moravian settlers arrived in Bethabara.
1766, January 6	Moravians began building Salem. Eight Brethren moved from Bethabara to Salem in February.
1766, August 18	Moravian Sisters visited Salem; the first lovefeast was held in Salem.
1770, July 4	Salem's God's Acre was laid out.
1771, March 31	The first early Easter morning service was held in Salem.
1771, November 13	Gemein Haus was consecrated, and the Salem Congregation was organized.
1772, January 24	Salem's "choir of musicians" played for the first time.
1772, March 30	Five Single Sisters moved from Bethabara to Salem. They lived in the Gemein Haus.
1772, April	The Girls' School opened with three students and one teacher, Elisabeth Oesterlein, in the Gemein Haus.
1786, April 5	Single Sisters moved into their new house.
1791, May 31	George Washington visited Salem and spent two nights in the tavern.
1798, May 22	The Tannenberg organ was played in the Gemein Haus for the first time.
1800, November 9	Home Moravian Church was consecrated.
1804, May 13	The first three boarding students arrived in Salem; the fourth student arrived three days later.
1805, July 16	South Hall was dedicated.
1841	A swap occurred in which the Girls' Boarding School received the Gemein Haus and the school paid for a new house for the pastor and a new chapel.
1856, March 24	Salem Female Academy's Main Hall was occupied.
1873	South Hall was renovated, with one and a half stories added.
1878, June 20	Diplomas were issued to graduates of Salem Female Academy for the first time.
1907	Salem Female Academy was renamed Salem Academy and College.
1907, December 24	Home Moravian Church distributed candles to everyone in the congregation during Christmas Eve services, not just to children.
1912	Salem Academy and College separated academically.
1913, May	Neighboring towns Winston and Salem joined to become Winston-Salem.
1929, December 16	Home Moravian Church's Woman's Auxiliary displayed a "big Putz" during the Christmas season. This was later known as the "Candle Tea."
1930, August 31	Three new buildings at Salem Academy were dedicated in honor of Mary Fries Patterson, Caroline Fries Shaffner, and Emma Fries Bahnson.
1950, March 30	Old Salem, Inc., was established as a nonprofit organization to acquire and preserve or restore "the historical monuments, buildings, sites, locations, areas, and/or objects" located in Forsyth County, North Carolina. From this founding came the restored buildings and homes that make up Old Salem.
1966, Autumn	A book room was opened by the Board of Christian Education and Evangelism. The book room moved in 1977 to a building on Main Street and became the Moravian Book and Gift Shop.
2002	The Toy Museum opened. Announcement of its closing came in April 2010.
2006	Old Salem, Inc., changed its name to Old Salem Museums and Gardens.
2007, April 22	Restored Single Sisters' House was rededicated.
2010	Old Salem Museums and Gardens celebrated the 60th anniversary of its founding.

Bibliography

Bivens, John Jr. and Paula Welshimer. *Moravian Decorative Arts in North Carolina: An Introduction to the Old Salem Collection.* Winston-Salem, NC: Old Salem, Inc., 1981.

Crews, C. Daniel and Richard W. Starbuck. *With Courage for the Future: The Story of the Moravian Church, Southern Province.* Winston-Salem, NC: Moravian Church in America, Southern Province, 2002.

Davis, Chester. *Hidden Seed and Harvest: A History of the Moravians.* Winston-Salem, NC: Wachovia Historical Society, 1959.

Eller, Aurelia Gray and Paula W. Locklair. *Old Salem Brought to Life: The Paintings and Story of Pauline Bahnson Gray.* Winston-Salem, NC: Old Salem Museums and Gardens, 2007.

Griffin, Frances. *Less Time for Meddling: A History of Salem Academy and College, 1772–1866.* Winston-Salem, NC: John F. Blair, 1979.

———. *Old Salem: An Adventure in Historic Preservation.* Winston-Salem, NC: Old Salem, Inc., 1985.

Howett, Catherine. *A World of Her Own Making: Katharine Smith Reynolds and the Landscape of Reynolda.* Amherst, MA: University of Massachusetts Press, 2007.

James, Hunter. *Old Salem: Official Guidebook. Revised edition. Edited by Frances Griffin.* Winston-Salem, NC: Old Salem, Inc., 1982.

Moravian Meanings: A Glossary of Historical Terms of the Moravian Church, Southern Province, 2nd edition. Winston-Salem, NC: Moravian Archives, n.d.

Niven, Penelope. *Old Salem: The Official Guidebook.* Winston-Salem, NC: Old Salem, Inc., 2000.

Owen, Mary Barrow, ed. *Old Salem, North Carolina.* The Garden Club of North Carolina, 1941.

Pfohl, Bernard J. *The Salem Band.* Winston-Salem, NC: Winston Printing Company, 1953.

Rondthaler, Right Reverend Edward. *Appendix to the Memorabilia of Fifty Years, Containing Memorabilia of 1928, 1929, 1930.* Raleigh, NC: Edwards and Broughton, 1931.

———. *The Memorabilia of Fifty Years, 1877 to 1927.* Raleigh, NC: Edwards and Broughton, 1928.

Salem College: The Dale H. Gramley Library Issue, March 1974. Winston-Salem, NC: Salem College, 1974.

Taylor, Susan. *Sisters.* Winston-Salem, NC: Salem Academy and College, 2004.

INDEX

www.arcadiapublishing.com

Discover books about the town where you grew up, the cities where your friends and families live, the town where your parents met, or even that retirement spot you've been dreaming about. Our Web site provides history lovers with exclusive deals, advanced notification about new titles, e-mail alerts of author events, and much more.

MADE IN THE

Arcadia Publishing, the leading local history publisher in the United States, is committed to making history accessible and meaningful through publishing books that celebrate and preserve the heritage of America's people and places. Consistent with our mission to preserve history on a local level, this book was printed in South Carolina on American-made paper and manufactured entirely in the United States.

This book carries the accredited Forest Stewardship Council (FSC) label and is printed on 100 percent FSC-certified paper. Products carrying the FSC label are independently certified to assure consumers that they come from forests that are managed to meet the social, economic, and ecological needs of present and future generations.

FSC
Mixed Sources
Product group from well-managed
forests and other controlled sources

Cert no. SW-COC-001530
www.fsc.org
© 1996 Forest Stewardship Council

Find Your Place in History.